harmony of reflected light

THE PHOTOGRAPHS OF ARTHUR WESLEY DOW

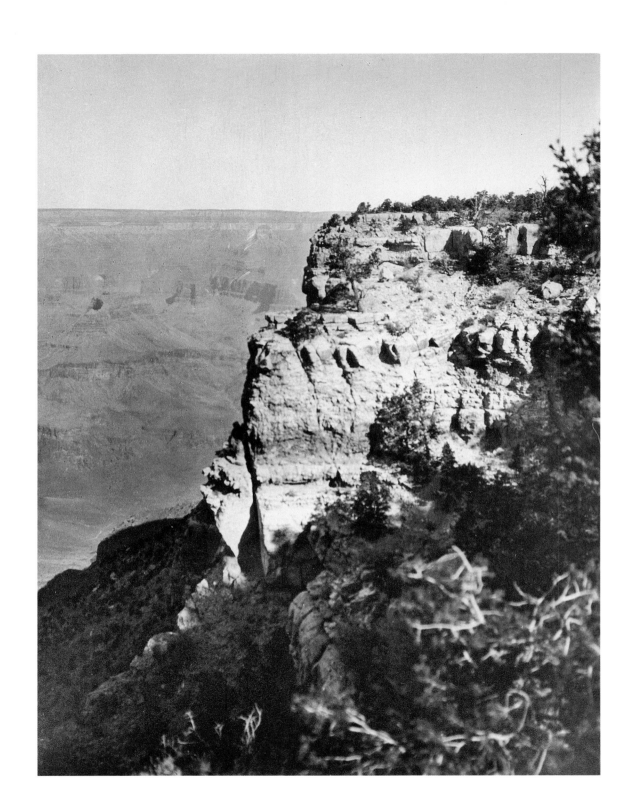

harmony of reflected light

THE PHOTOGRAPHS OF ARTHUR WESLEY DOW

JAMES L. ENYEART

FEATURING THE COLLECTION OF
BARBARA AND GEORGE WRIGHT

MUSEUM OF NEW MEXICO PRESS
SANTA FE

IN ASSOCIATION WITH THE
ANNE AND JOHN MARION CENTER FOR PHOTOGRAPHIC ARTS

Harmony of Reflected Light: The Photographs of Arthur Wesley Dow accompanies an exhibition organized by the Anne and John Marion Center for Photographic Arts in association with the Museum of Fine Arts, Museum of New Mexico, Santa Fe.

Project editor: Mary Wachs

Manuscript editing: Ann Mason

Design and Production: David Skolkin

Composition: Set in Sabon with Futura Display.

Manufactured in Singapore.

10 9 8 7 6 5 4 3 2 1

Library of Congress Cataloging-in-Publication Data
Enyeart, James L.
 Harmony of reflected light : the photographs of Arthur Wesley Dow / by James L. Enyeart.
 p. cm.
 Includes bibliographical references.
 ISBN 0-89013-383-2 (cloth)
 1. Photography, Artistic—Exhibitions. 2. Dow, Arthur W. (Arthur Wesley),
1857–1922—Exhibitions. I. dow, Arthur W. (Arthur Wesley), 1857–1922.
 TR647 .D69 2001
 779'.092—dc21

 00-068716

Museum of New Mexico Press

Post Office Box 2087

Santa Fe, New Mexico 87504

Frontis piece: Grand Canyon, "From Hopi Point, Shiva Temples Edge At Top Right", Silver Print, 1911

Contents

Acknowledgments

THIS BOOK IS THE RESULT OF COLLABORATION with many individuals who shared their ideas, expertise, and resources. In particular, I am deeply grateful to an anonymous donor whose love of the arts made this book possible by providing a level of support that ensured the best possible reproductions of Arthur Wesley Dow's photographs.

A special tribute is also due Barbara D. Wright, great-grandniece of Dow, who preserved his work for posterity. Her gracious assistance in researching aspects of Dow's life and work was essential, and her afterword offers valuable information on the provenance of the collection and insights into the Dow family. Her generosity in making the collection available will be appreciated by all. I am grateful to George Wright for his help in preserving and caring for the collection, and I am equally grateful to other members of the family who have lent works by Dow: Warren and Jennifer Wright and Robin O'Brien.

Roy Pedersen, friend of Barbara Wright, has long been a promoter of Dow's photography. I wish to thank him for the loan of his collection, his assistance and for generously sharing his research on Dow's photography.

I also wish to acknowledge and thank Ira Jackson for his ardent friendship and early guidance in developing this project. Additionally, the Marlene Nathan Meyerson Family Foundation and the Museum of Fine Arts of the Museum of New Mexico also provided essential support for the exhibition. I am especially indebted to Stuart Ashman, former director of the museum, for his interest in presenting the exhibition that the following book accompanies, and to Mary Jebson, acting director of the museum, for her support and cooperation.

Joy S. Weber, daughter of Max Weber, generously shared copies of her father's interviews. Christian Peterson, curator of the Minneapolis Institute of Arts, kindly shared his knowledge and exceptional insight into photography's role in the American Arts and Crafts movement.

I appreciate the craftsmanship of James Hart, who provided the transparencies for reproduction of Dow's works, and his keen interest in Dow as a photographer. I would also like to thank Kirsten Gerdes, my assistant at the Anne and John Marion Center for Photographic Arts, College of Santa Fe, who balanced the many needs and responsibilities of all of those who contributed to the project.

Five students at the Marion Center—Eliza Blagdon, Kathryn Buntin, Ellen Miller, Strahan McMullen, Amanda Sibley—deserve special recognition and appreciation for their roles in assisting me in researching the book and in producing the exhibition. Their enthusiasm provided a special energy that helped keep the project successfully on deadline.

I am indebted to the staff of the Museum of New Mexico Press for their support and commitment to the book, especially Mary Wachs, a most talented editor; David Skolkin, a wonderfully creative designer; and Anna Gallegos, for her dedicated efforts in marketing.

Finally, I owe the very core of this effort and all my attempts at writing about photographers and other artists to Roxanne Malone, whose efforts have always provided an environment conducive to writing and whose dialogue, as an artist herself, has always engendered the content of my writing with a sense of obligation to the poetry of facts.

I N RECENT YEARS, THERE HAS BEEN a revival of interest in Arthur Wesley Dow's work and in his role as an influential artist who spread his talents between teaching and image-making. During his lifetime, which spanned the turn of the century, American art underwent extraordinary changes, moving from romantic and pictorial manifestations to the aesthetic developments of the modernist era. So radical and fundamental were the ideas and philosophies of art engendered by artists during this period that much of contemporary art in the twenty-first century remains tangentially, if not directly, related to one or another of the dozens of offshoots of modernism. The renewed interest in Dow's work accompanies a wide-ranging review by historians and curators of the integral aspects of modernism in the work of America's artists, individually and collectively. At the turn of the millennium, nearly every museum in the country presented an exhibition about this most salient period, or has plans to do so. It is in this context, coincidentally, that Arthur Wesley Dow can now receive appropriate critical assessment and presentation of his work as a photographer and his impact on pictorial and modernist photography.

From 1934 to the present, there have been several monographs produced about Dow as a painter and propagator of the Arts and Crafts movement, including a brief biography. Numerous histories of American art and monographs on artists who were either his students or within his realm of influence (Georgia O'Keeffe, Max Weber, Alvin Langdon Coburn) make reference to Dow as teacher but rarely as an artist of influence. As a photographer, he is acknowledged only in passing, at best. In the literature on Dow, his photography is given only the briefest mention, while his students who were photographers and those acquainted with his pedagogic ideas (Coburn, Clarence White, Gertrude Käsebier, Karl Struss) customarily receive serious regard. In large part this has been due to lack of a sizable body of known photographic work by Dow and, in his lifetime, to very limited exhibiting of his photographs, even during his years of greatest exposure at the Montross Gallery in New York. The art world has been aware of a relatively small number of

cyanotypes made in and around his home and inspiration, Ipswich, Massachusetts.[1] These small, contact-print, blue-tone photographs were not sufficient in number or varied enough in subject to reveal their maker's full artistic intentions. Historians have generally treated these prints as either sketches for his primary media—painting and woodblock—or as isolated, brief flirtations with photographic technique.

In 1999, the potential to see Dow as a serious figure in the history of photography in connection with his own photographs changed dramatically. The great-grandniece of Dow, Barbara D. Wright, contacted the present author with an invitation to view a collection of nearly two hundred photographs by Dow created using a variety of photographic processes (silver, platinum, gum bichromate, and cyanotype). Additionally, several other collections were identified that had been passed on to family members and acquired by a close friend. A selection of 135 of these works, including several from the Museum of Fine Arts in Santa Fe, comprise the current volume and attendant exhibition. The history of this collection, which has remained in the Dow family since his death in 1922, is documented in the afterword to this volume, written by Barbara D. Wright, who for decades had promoted her great-uncle's work among historians and curators but found only passing interest in his photography. Both a wider acceptance today of Dow's contributions as an artist and of photography itself over the past several decades helped to coalesce events that resulted in this book and exhibition.

The period in which Dow made the majority of his photographs extends from 1890 to 1912. During this time he explored a variety of printmaking media, including etching, woodblock, and zinc half-tone blocks, which prepared the way for his early acceptance of photography as an extension of his artistic interests. Alfred Stieglitz, the Photo-Secession, and early pictorialist photography all informed Dow's photography to a considerable extent, but it was his own intuitive vision, first refined in his drawings and paintings executed in France prior to 1890, that set him on his course. Dow's venture as a young man into the demimonde artistic environs of the Académie Julian in Paris and the artists' commune of Pont-Aven in Brittany are well-known aspects of his development as an artist. What has been missing, however, is the impact of that period of his life (1884–89) on his photography and his ideas relative to modernism. Continuity among his drawings, prints, and photographs reveals this work to be his most spontaneous and, perhaps, strongest, with examples that range from the beginning of his career to the end of his life.

In 1934, Arthur Warren Johnson, an Ipswich historian, wrote a biography of that town's favorite son, Arthur Wesley Dow, for the Ipswich Historical Society (Johnson 1934). Every subsequent publication about Dow has relied on the biographical information, and in some cases Dow's aesthetic sources, contained in Johnson's short text of about one hundred pages. It is clear in this rare volume that Johnson was too much the admirer of Dow to have critically explored his life in relation to his art, although it accurately reveals that art was Dow's chief lifelong dedication. There

can be little doubt that, in constructing Dow's biography, Johnson had access to Dow's widow, other family members, and to a substantial body of personal papers. Much of that material can be found today in the archives of the Ipswich Historical Society, the Archives of American Art, and in the collection of Barbara D. Wright. There remains, however, a pall over the content of the biography, for of the some "ten thousand letters, Mr. Dow's note-books, journals and lecture notes" that Johnson relied upon (Johnson 1934, 1), "[m]ost . . . mysteriously disappeared after Johnson's death in 1949," according to the Archives of American Art, where the Dow archive is housed. This statement suggests that while it is impossible therefore to corroborate much of the material presented in the biography, it is also true that the surviving materials, including signed and dated works of art, do not present significant variance from the general chronology of the biography.

Biography is important to the discussion of Dow's photography because issues of artistic identity and personality are as central to his decision to investigate photography as are his interactions with other artists and movements of the time. The Johnson biography, balanced with a fleshing out of major events in Dow's life and work by subsequent historians and new sources of surviving notes and correspondence, collectively reveal the richer complexity of this artist. The pathway to Dow's sense of photography as a recognized art is not easily revealed. It requires drawing together a web work of memories, experiences, influences, and ideas that ebbed and flowed throughout his life. At times his love for the arts pushed him to the brink of the avant-garde, and at other times it caused him to wrap himself in a security blanket of nostalgia and the comfortable rewards of immediate feedback that accompanied teaching. As modernist ideas grew from discussion into practice among the Stieglitz group at "291," a split began to develop among the Photo-Secessionists. But it was not just Stieglitz's eager incorporation of the abstract elements of modernism that caused a break with many of the Photo-Secessionists and an end to the group as an association of pictorialists. It was also the pressure of the time in which some photographers, such as Alvin Langdon Coburn, Gertrude Käsebier, and Clarence White, had already incorporated modern elements of the Symbolists and Arts and Crafts movement into their works without resorting to abstraction. The influence of Dow on that process was immense. He inspired in such artists a somewhat more positivist approach to the encroachment of modern industrial and material society on the arts. As a New Englander, he saw little inspiration in the aggravation of urban progress for art and continued to resolve the changing social order under the umbrella of nature. This involvement among the leaders of American photography in the first two decades of the twentieth century places him and his own photography well within the eye of the storm.

1. Several books by Nancy Green, historian and curator at the Herbert F. Johnson Museum of Art at Cornell University over the past several years, have included one or two silver prints by Dow. Also, one or two platinum prints may be found in museum collections, including the Museum of Modern Art in New York. In general, however, the art world has not had access in literature or collections to photographs by Dow other than periodic reproduction of cyanotypes.

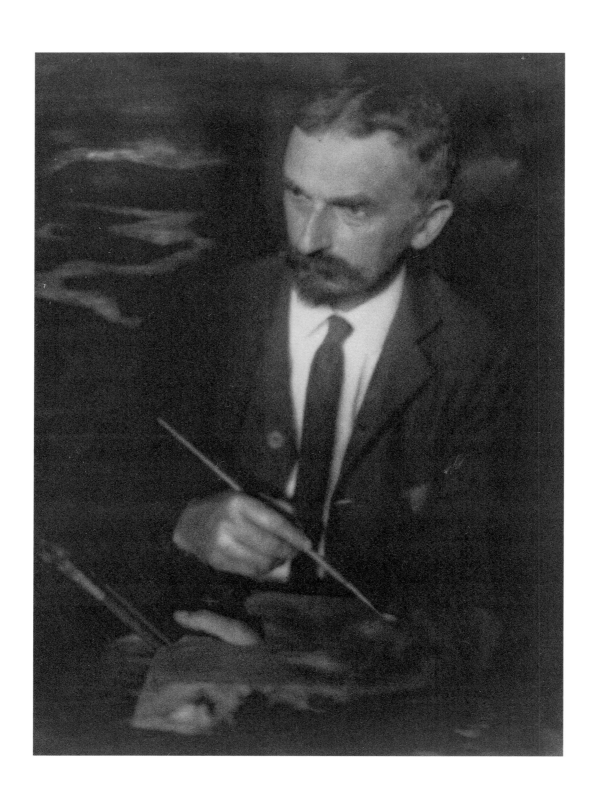

1

PORTRAIT OF DOW, IPSWICH

Platinum print, ca. 1905

Photographer unknown

Arthur Wesley Dow is predominately known as an innovative professor of art who provided the teaching world with a unique philosophic approach for training young artists from kindergarten to college. During his tenure at Pratt Institute and Columbia University's Teachers College from 1895 to 1922, he introduced a mixture of Asian and Western concepts of aesthetic structure that revolutionized the teaching of art and demystified what it means "to have an eye." He advocated a creative means of building composition through a careful plan of design and harmony of reflected light and dark, as he described it (Dow 1997, 67). The publication of his book *Composition: A Series of Exercises in Art Structure for the Use of Students and Teachers* in 1899 changed forever the previous academic teaching model of imitation, reliance on nature, and unedited reality.

Dow is also regarded as a fine painter, but not with the same influence or level of accomplishment as is accorded such peers as Maurice Prendergast and Robert Henri. Left out of the art historical mainstream, Dow was, nevertheless, ahead of his time in terms of modernist ideas, though he remained a romantic to his death, a seeming contradiction that only now is beginning to be understood. In his day Dow's flat, semiabstract, patterned landscapes appeared simplistic and out of touch with the industrial and urban changes taking place in the world and with the developments embodied in the work of Gauguin, Rodin, Matisse, and other early modernists. His sense of the abstract, which was the driving artistic interest of the time, was highly intellectual and not socially motivated as was that of the majority of artists who sought recognition in the art world.

Dow was a product of a New England village, which forever conditioned his love of nature and prejudiced his attitude toward cities and the growing mechanization of society. Even though he lived in urban centers such as Paris and New York for much of his life, he always retreated on an annual basis to his home in Ipswich and to Pont-Aven in the province of Finistère, while studying in Paris. His greatest influence on photographers, the Arts and Crafts movement, and painters

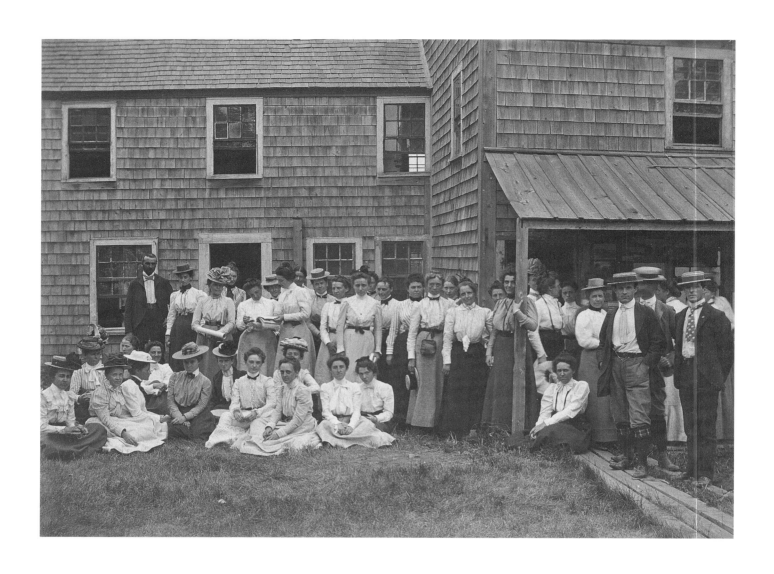

2

IPSWICH CLASS

Cyanotype, ca. 1900

Collection of Roy Pedersen

took place at his own Ipswich Summer School of Arts between 1900 and 1907 (fig. 2). It was here that artists such as Alvin Langdon Coburn came into contact with Dow's artwork, as well as with his philosophy and aesthetics. It was also in Ipswich that Dow explored in depth common aesthetic qualities of various artistic media, including woodblock printing, heliography, and photography. At Columbia University his influence was as a teacher, not as an artist. This tension between his intense desires to be a recognized artist and a leading teacher had its roots in his person and personality.

More is known about Dow's professional life than about him as a person of deep religious convictions with specific personality traits that affected his life as an artist. The majority of art historical texts written about Dow reveal only the aspects of his personality necessary to describe the setting and the chronology of his life. But this book and the exhibition it accompanies require a deeper analysis of Dow the person because they present for the first time a comprehensive look at his photographs, which have not been considered a major part of his oeuvre. The following reproductions of his photographs, made by a variety of processes, reveal that Dow's decision to forego life as a painter was due primarily to particular personality traits that simultaneously stimulated his interest in other media. Although he rejected media reviews and criticism as corrupt and self-serving means by which artists could "buy their way in," he was also frustrated with his inability to sell sufficient work to support himself and a future family (Johnson 1934, 51). Having grown up in extremely modest and often poor surroundings, he had no desire to repeat the hand-to-mouth existence provided by his father. Thus, teaching repeatedly became the answer to his insecurity and his hope for having a profession that would allow him to lead the life of an artist. In the beginning, before his study in Europe, he was convinced that becoming a painter required complete dedication of one's time and consequently was willing to accept modest contributions to sustain him until he could support himself through painting. In the 1890s, after study in Europe, he continued to believe in his chosen mission, but his shy nature could not sustain artistic passion in the face of the anxiety of living on the edge of poverty. As his time for painting began to be eroded by teaching, he turned to other artistic media, especially printmaking and photography, which allowed for more prolific output while satisfying his need to be creative.

Dow's photography had perhaps a greater impact on American modernism than his painting, but this is only apparent through historical perspective. Dow would have hidden his substantial interest in photography from his contemporaries because of the intense interest in the medium as an art form by others who had made it their primary focus. He did not want to be known as a photographer but as a painter, and at the time he was even indecisive about that commitment. By 1890, when Dow began making artistically mature photographs, Alfred Stieglitz was already becoming a forceful leader in the field. In 1899, the same year he published *Composition,* Dow wrote a review of Gertrude Käsebier's photography for *Camera Notes,* edited by Stieglitz. The title of his review, "Mrs. Käsebier's Photographs, from a Painter's Point of View," made it clear that he was speaking

as a painter in order to embrace Käsebier's work as a part of the larger art world. But some time before this, probably around 1895, Dow reportedly won first prize in a contest sponsored by the Boston Photograph Club (Moffatt 1977, 145). Also at this time Dow was contemplating life as an artist in the context of philosophical and aesthetic issues, about which he was as passionate as his inherent religious beliefs. Focusing on a range of media in an ecumenical manner during the 1890s, Dow gained increasing knowledge of Japanese art, characteristics of which he combined in a unique synthesis with aesthetic qualities absorbed during his earlier European training as a painter (1884–89). The primary artistic application of this new approach to composition and design was classical woodblock processes influenced by Japanese masters. His interest in printmaking in general, which included intaglio while in France, laid the groundwork for serious interest in photography, which was for him just another, newer printmaking medium. The readiness with which he accepted and used a variety of new and old media that were not considered mainstream reflected his perception of himself as an open-minded artist willing to experiment and interested in the uniqueness of each artwork.

The story of how Dow's personality affected his artistic endeavors is the tale of a shy yet determined young man who was deeply religious with strong convictions about the nature of humanity.

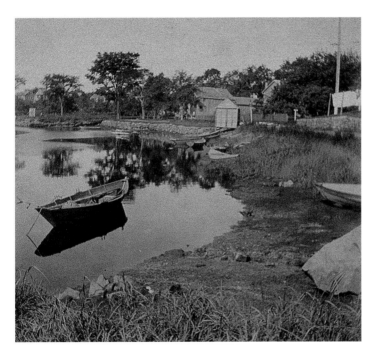

3

IPSWICH RIVER AT HOWARD DODGE'S

Silver print

ca. 1890

Even in maturity Dow's personal characteristics and innermost drives profoundly affected his decisions as an artist. In *Composition*, Dow wrote, "Art resists everything that interferes with free choice and personal decision; art knows no limits. No work has art-value unless it reflects the personality of its author" (Dow 1997, 97). Although this is true of all artists in varying degrees, in Dow's case his choices in life had a direct impact on his options as an artist, making his creative contributions all the more extraordinary (fig. 1).

Dow was born in 1857 in Ipswich, Massachusetts, a beautiful town of seventeenth-century houses and a strong New England Puritan preference for the simple and severe, situated along the coast amidst meandering marshes, bone-white dunes, and the ever-changing spectacle of the ocean (figs. 3 and 4). The houses reflected the craftsmen's understanding of harmony of line and proportion but within the

DOW HOME SITE, IPSWICH,

"OUR BACK YARD"

Cyanotype, ca. 1890

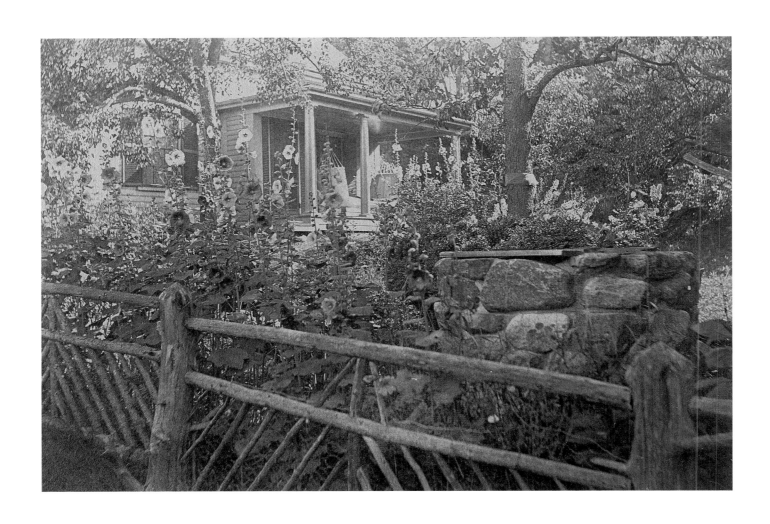

5

DOW HOME, SPRING STREET, IPSWICH

Cyanotype, ca. 1890

Collection of Museum of Fine Arts, Santa Fe

limits of a theocracy wary of excess. Dow's family home after 1861, built by his father, was a rustic mix of early Victorian style, typical of the era (figs. 5 and 6). The geometric design of the rough-hewn poles that made up the fence, which was the center of attention for this modest house, blended with the abundant surrounding foliage and flowers in a most pictorial manner.

Dow's biographer Arthur Warren Johnson describes him as being from a poor family, but in actuality their financial state fluctuated greatly as his father worked in a variety of trades from carpenter to handyman. His father was a strict Congregationalist who also played the violin and wrote often in his diaries about natural phenomena (fig. 7). His mother, described by Johnson as a true New England lady, was totally devoted to her family, which after the death of his sister in infancy, included only Dow and his younger brother, Dana (Moffatt 1977, 11–12). According to Johnson and subsequent historians, Dow's shy, sensitive nature caused his mother to be protective of him and shower him with affection. If Dow grew up different from his peers, more solitary and interested in subjects not of their rough-and-tumble ways, he did so in a creative manner. From his father he inherited a fine touch in working with materials, especially in restoring old clocks and other woodworking projects. From his mother he received a passion for reading and things that inspired visual pleasure. Throughout his life he spoke of beauty as if it were an ethereal obligation of imagination and the goal of all aesthetic effort.

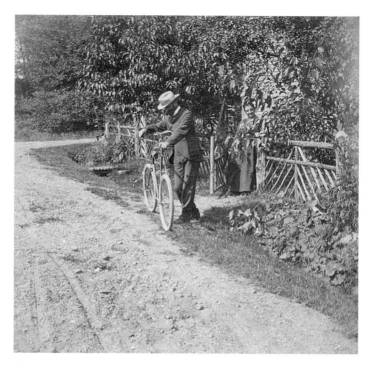

6

SPRING STREET,

ARTHUR WESLEY DOW AT HIS GATE

Silver print, ca. 1900

Educationally Dow was in his element and graduated from high school in 1875 as valedictorian. If the fortunes of the family had allowed him to attend college, he would have been easily accepted at Amherst, with his talent for language (French) and literature. However, even though he could not go to college, because he was known in Ipswich as a young man of scholastic aptitude he was offered a position teaching elementary grades in a parish school. This first recognition as a teacher was to have a lasting impact on the decisions he would later make concerning the competing issues of being an artist and teacher.

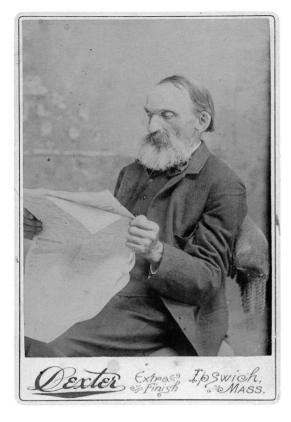

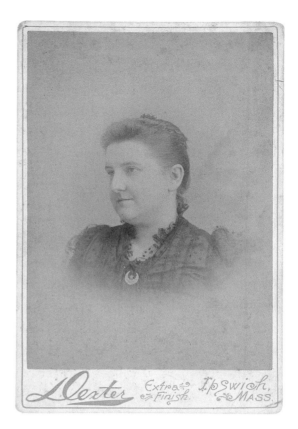

7

DAVID FRANCIS DOW

(ARTHUR WESLEY DOW'S FATHER,

AGE SEVENTY), IPSWICH

Albumen print by Dexter Studio, July 20, 1890

8

MINNIE DOW, IPSWICH

Albumen print by Dexter Studio

ca. 1890

As an aspiring artist in his early twenties, Dow had several mentors and patrons in Ipswich and Salem: a librarian, a blind scholar of classics (Dow learned to read Greek poetry in the original ancient language and translated French religious texts), a culturally informed Puritan minister, and a wealthy merchant family. The classicist with whom Dow studied, the Reverend John P. Cowles, enhanced Dow's self-confidence and inspired him to view the arts in a more integrated manner. Johnson said of this intellectual endeavor, which lasted several years, "The classical restraint implicit in this work became gradually a part of Dow's attitude toward life, molded his habits of thought, and perhaps in later years, when he had become an artist gave strength to his innate romanticism" (Johnson 1934, 5).

Encouraged by friends and mentors, in 1881, at age twenty-four, Dow first studied with a modestly successful painter in Boston, James M. Stone. It was there that he met his future wife, Min-

nie Pearson, of Lowell, Massachusetts, also a student of Stone's (fig. 8). This was a period of important events that molded his personal and professional future and greatly affected his ability to deal with the vicissitudes of life. Setting the stage for the great leaps he was about to make was the death of his mother, to whom he was very close. Although this pivotal event could have caused him to retreat to the quiet of Ipswich to live out life as an amateur artist, since she had been his inspiration for a life in the arts, Dow summoned the courage to follow a more daring path.

Thus, though he had lost the rudder provided by his mother's strength, Dow began to explore the totality of his being in connection with art. Visiting museums, libraries, and churches of Boston, Dow's eyes were opened to the relatedness of certain aesthetic manifestations of poetry, art, and religious structures. Emerging from the restraints of his Puritan past and attending Episcopalian services at St. John the Evangelist, he discovered a visually rich environment that allowed him to integrate both his passions for religion and art for his life's mission. In Johnson's words, the church offered Dow ". . . the beauty of its services, the color and the picturesque dignity—a form of art" (Johnson 1934, 20).

During these same years, Dow befriended Frank Duveneck, an older painter of international stature who taught art classes, produced paintings for Catholic churches, and by studying in Europe had broken with traditional American realism in favor of a style similar to that of Whistler, an artist already admired by Dow. Here was a new mentor for Dow who encouraged his formal training in Europe at the Académie Julian, considered by the Boston art world to be the leading school for professional artists.

Although Dow met Minnie Pearson at about this time (1881), it was only in 1893, after his return from France, that they finally married. Having many of the same qualities as Dow's mother, Minnie assumed a role as supporter of Dow's artistic passion. Minnie was an aspiring artist, had a strong nature, was from a financially secure family, and was passionately literate. Together, she and Dow read the complete works of Shakespeare and works by Byron, Longfellow, and other poets. Perhaps most importantly, she encouraged Dow to aspire to excellence as an artist by studying in Europe.

With his marriage to Minnie, Dow's self-confidence soared, and he became a talented teacher at several New England schools and also had modest success selling his paintings. With increased personal harmony, a newly found religious freedom, and the promise of broader artistic horizons, he was inspired to focus his excitement through "prayers each morning and night before a crucifix between lighted candles" (Johnson 1934, 25). Such an activity was a considerable departure from his Puritan background, and Dow's growing passion for experimentation and independence soon affected all his endeavors with the result that, in 1884, he departed for study in Paris.

Upon arrival at the Académie Julian, Dow faced a conflict of desire. Intellectual and reserved, he wanted to immerse himself in his studies to follow his dream of being a painter, but he was immediately confronted with a rowdy group of young male bohemians who were interested as

21

much in the *joie de vivre* as they were in becoming artists (figs. 9, 10, 11). As a result, many never attained the ultimate goal of the school's training: to have work shown in the Exposition Universal, an enormous salon to which ten thousand artists submitted works while only two thousand were chosen. Dow's self-discipline at the school is reflected in the fact that after five years he was not only selected to show his work but was given an honorable mention. Although the majority of the students were serious about their desire to become professional artists, the Académie Julian was already considered by leading painters of the time to be a remnant of romantic traditionalism, especially in view of the impact impressionists were still having on international art. But for Dow, serious study among peers, no matter their moral turpitude, as well as the opportunity to test himself against the classical teaching methods of a leading Western European art school, were invaluable for refining his sense of painting's potential. In describing a typical day at the school, Dow said, "I think there were more than 50 men in this room. Upon the platform was the model—a woman this week. . . . The model rests every 3/4 hour and at the first rest—the boys began to shout 'nouveau' and they made one fellow—E. C. Tarbell—mount a stool amid a tremendous uproar. . . . One boy put his hand on the nouveau and said 'Un beau nouveau, messieurs, un beau nouveau.' Then the whole crowd yelled Chantez Chantez" (Green 1999, 14).

Despite the knowledge gained at the school, however, years later in a lecture on "modernism in art" Dow acknowledged the limitations of its methods: "I confess a sympathy with all who reject traditional academicism in art. I often regret the years spent in the Académie Julian where we were taught by professors whom we revered, to make maps of human figures" (Green 1999, 14). In making this assessment he, of course, excluded his experience at Pont-Aven, one of the world's great art colonies, where he met Gauguin and members of the Nabis, and became interested in Japanese art, modernism, and photography—thus discovering his own path as an artist.

Evidence of Dow's gentle and caring personality, as well as his evolving beliefs about artists, is apparent in letters to his younger brother Dana from Paris and Pont-Aven, including the following written in 1884:

> Don't take example from anybody but just look to the One who is perfect. . . .
> Now in the very beginning of your Christian life try to look at all things fairly and
> calmly. Make up your own mind firmly and stick to it—at the same time do not
> be prejudiced against other religions and beliefs. If someone had only told me this
> I should have been saved much trouble. As you grow older you will find that there
> are points of good in all beliefs. Now if I can tell you anything just write me and
> I shall be delighted to help you all I can. My own life has been so imperfect that I
> shrink from advising anybody, yet I have had some experience which might help
> you (pers. com. 1884).

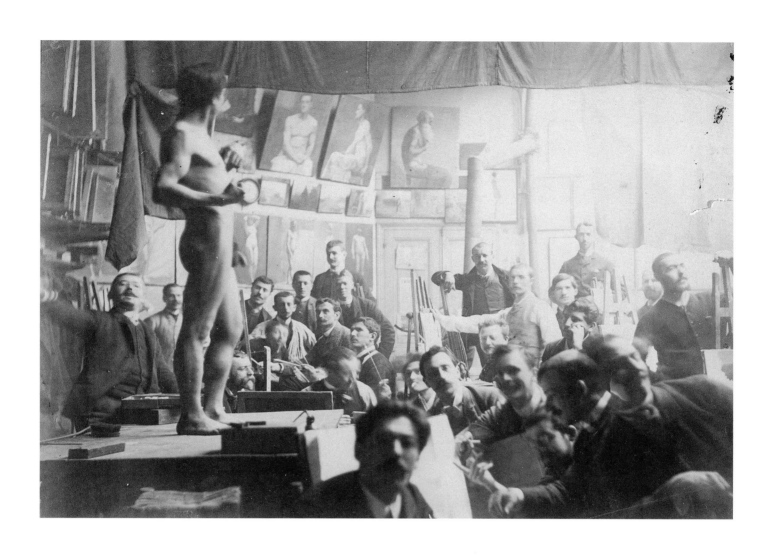

ACADÉMIE JULIAN, PARIS,

DRAWING CLASS WITH MALE NUDE

Albumen print, 1885

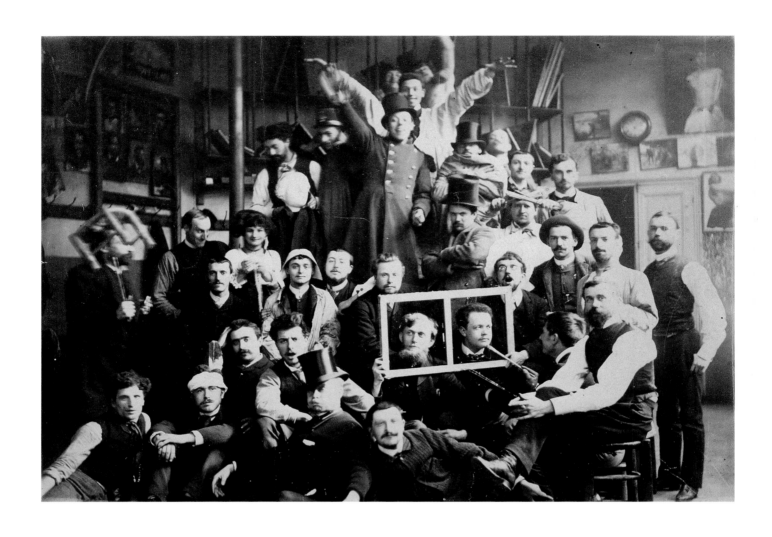

10

ACADÉMIE JULIAN, DOW AT REAR RIGHT

Albumen print by B. T. Newman, ca. 1885

11

CONCOURS DE PORTRAIT,
ACADÉMIE JULIAN, DOW IN REAR
CENTER OF ROOM

Albumen print, April 10, 1886

Later appointed Dana's official custodian, Dow exhibits in this letter his inherent desire to guide others that characterized his outstanding teaching career from the time of his first position at age eighteen until the time he established his own first successful school for painting nearly a decade later.

In another letter to Dana written from the Hotel de la Gare in Concarneau, Finistère, in 1886, Dow counseled his brother in the ways of the world:

> You have done well to go into the store, and I am sure you will have success. You like business life I think, and why not plunge right into it? It supplies present need anyway and you will gain practical knowledge of the world and people, which will be invaluable. . . . I have thought a great deal about your education and have worried because you could get no more schooling, but perhaps you do not need any more. If you don't care for a professional life, you surely have all the education you need. I mean schooling, "book-larnin". . . . A man must start out into the world sometime and gain a practical knowledge by dealing with men. You can keep up your habit of reading—keep yourself well-informed on all important subjects and you will have an education of priceless value to you. My stay over here has given me experience and you may be sure that my advice as far as it goes, is sound truth. Read up about the church, its foundation and history and especially the principles and doctrine of our own denomination, and the grand ideas of the pilgrim fathers—to them we owe all we are as a nation.
>
> If you are to be a business man you should understand all the things pertaining to commerce—banks, stocks, commercial laws, and all the principles of trade. Want of self-confidence is a great hindrance to anyone, but it is caused by *ignorance*. . . . A rule which the best of the artists apply to their work, will be a help to you. "Whatever is worth doing at all, is worth doing *well*." . . . Mother always taught us to be thorough. . . . In painting, it is generally the poor work that goes to the wall. It is the lazy artist that lives in the garret. But I won't give any more advice. . . . If the present is well attended to, the future will take care of itself (Wright Collection).

Dow similarly nurtured young aspiring artists. He became the leading teacher of art in America at Pratt Institute and Columbia Teachers College. A testimony to this is the following commentary by the great modernist painter Max Weber, who was Dow's student from 1898 to 1900: "When you ask me who was my greatest teacher, it was Dow. . . . Tall, French bearded, very, very amiable, dignified—a picture of what we should call gentle . . . he had his finger on the very things that came in Paris only after Cézanne. . . . When I lectured on the history of art—say I would talk

on Rembrandt—somehow I would bring in a front elevation of a cathedral, or an instrument of East India, or the rugs from China. Design. Geometry. I learned that from him."[1] Weber reinforces the image of Dow as the type of individual who would not have participated in the battle emerging in Stieglitz's circle to position photography within the arts. At the same time, the letter reveals Dow's intense commitment to the integrated nature of all artistic media and the rejection of prejudice against any. At the end of the nineteenth century, for a painter such as Dow this was an important attitude for the investigation of photography as an artistic medium. The photographs he made beginning in the 1890s reveal that there were many aspects to his exploration of the medium. He achieved in photographs a continuity in the massing of shape and tone similar to that attained in his woodblock printing and painting. He experimented with photography to learn about its potential visual qualities for abstraction of reality. And he also employed the medium's pictorial qualities to create images in a style based on Japanese woodblock prints.

By the early 1900s, after years of seasoning his interest in the arts and resigning himself to the necessity of working in New York to be at the forefront of his life as both artist and teacher, Dow revived an interest from his early years in Ipswich—cultural history, including arts and crafts, folklore, and ghost stories.

The following "ghost" story from a Dow manuscript that was written in 1915 reveals not only Dow's openness and his abiding interest in spirituality but also his views about the artistic process and his beliefs concerning the integration of life and art [the punctuation and emphases are Dow's]:

> One day, in my office at Teachers College, I received a telephone call from Dr. Hyslop, asking if I would examine some paintings and express an opinion as to their character, technique, value, and any influences if able. He hastened to say that money value was not meant, but their quality as art; that his request was not related in any way to the sale of the pictures. I told him that authorship is a difficult matter to determine, that it is the business of an expert critic who makes an intimate study of the life, style, and brush-work of individual painters.
>
> He replied that it was not a question of authorship but rather of a *degree* of excellence and of the influences that had affected the painter. I was mystified, but deeply interested, and gratified to have the opportunity of meeting Dr. Hyslop, and of being of some assistance to him in his investigations.
>
> We met in the Columbia Library. I remember him as a man of scholarly bearing, with dark eyes of most kindly expression. His hair was black he wore a full beard.
>
> From a package he produced and spread out a set of pencil drawings of storm blown trees, and a number of photographs of landscapes containing similar trees. He said that we would go down town to see paintings, but first he wanted me to

say *whether the drawings looked like the photographs!* I replied that they did, most closely, —indeed the resemblance was so obvious that I wondered at the question. I told him that the drawings seemed to have been made from the photographs, or also from nature, and the photographs taken as helps. This answer seemed to be all that he required.

We went down town, —I do not remember the exact locality and were ushered into the back parlor of an apartment house. I was introduced to the painter's wife and to the painter himself, a tall man in spectacles. The room was full of paintings, mostly of large size. They were stacked face to the wall, and a few more hanging on the wall. I noticed that the landscape was that of southeastern Massachusetts.

"Now Mr. _____" said Dr. Hyslop, "Show Mr. Dow your paintings." As they passed before me, Dr. Hyslop asked me to say *whose influence* I observed in them. This was a most embarrassing question, for the work seemed that of an unsuccessful painter, —one who had just missed the masterful touch. Knowing that every painter resents the accusation of being a copyist, I was in a dilemma, —made worse by the silent expectation of the other three. Finally, noticing the storm-blown trees, the sunny hillsides and salt marshes, I said that the work reminded me of R. Swain Gifford. Dr. Hyslop clapped his hands and exclaimed, "That is what we have been waiting for, —now Mr. _____ tell your story." Briefly it was this:

The author of the pictures said that he was not a painter but a goldsmith. While visiting the exhibition of the works of the late R. Swain Gifford, on Fifth Avenue, New York, he heard a voice say "See what I have done, —go and do likewise" (or words to that effect). From that moment he was impelled to paint.

As he walked New York streets he saw in the air the forms of storm-blown trees like Mr. Gifford's, and drew them in pencil. These were the drawings I had just seen. The photographs had been taken by Dr. Hyslop in Mr. Gifford's favorite sketching ground. This proved that the trees seen in vision were those of a definite though remote locality.

Procuring canvases and colors, Mr. _____ went to the island of Naushon where much of Mr. Gifford's work was done, and painted in Gifford's style. Pointing to a specifically good effect of sunshine and shadow, I asked him how he did it so well, —as painters regard such an effect very difficult to master. He replied that he did not know, —he simply mixed the colors on his palette and put them on the canvas, working under a mysterious *influence* that guided him.

The voice also directed him to *complete the unfinished paintings* of Mr. Gifford!

To test his own powers and to discover how much technique he had gained through psychic influence, he made a copy of Cabanel's "Birth of Venus" in the

Metropolitan Museum, New York. Considering the circumstances the result was surprisingly good.

When Dr. Hyslop and I were on our way home I asked him how he accounted for this strange manifestation. He answered that his investigations had convinced him of the existence of spirits, and that sometimes a spirit may get control of a person in this world. Most of us, he said, are insulated from such influences simply by living a normal life and attending to our regular work. Occasionally, however, we find a person unusually sensitive to spirit control, and unable to resist it. This was his explanation of the present case. He thought it possible that Mr. _____ could be freed by the help of a psychic.

I said that an artist would strongly object to the copying of his style, and furthermore—would prefer to have his unfinished works destroyed rather than finished by another hand, no matter how skillful. Dr. Hyslop agreed that this is true, and that it made the case still more puzzling, but he was confident of one thing, —that the evidence all pointed to spirit control.

His manner of conducting the investigation was a model for all who approach the subject of psychic phenomena.

He was calm, patient, scholarly and judicial. His was the spirit of the devoted scientist, — observing facts, comparing, weighing and drawing conclusions. We can well understand his criticism, in his later writings, of those self-satisfied ones who condemn without a hearing, who are not willing even to investigate.

In these days, when there is so much interest in psychic manifestations we may well take to heart Dr. Hyslop's sound and sensible advice, —to pay little heed to what supposed spirits say of the *other* world, as you can not check it up, but seek for evidence in what they say of *this* world (Dow n.d.).

In 1887, Dow returned to Ipswich from France, then in 1888 sailed again for Brittany and Concarneau, this time with Minnie and his fellow Académie Julian student Henry Kenyon (figs. 12 and 13). Apparently, Dow had decided not to return to teaching, which consumed all of his energies, and turned down a position at Oberlin that same year. After returning again to Ipswich in 1889, Dow's high hopes for living his life as an artist were dashed by the lack of favorable critical and commercial response to his painting over the next year. In assessing his work, he began to express doubts about the validity of his "French" paintings in the face of his great desire to be a new American painter. From correspondence of late 1890 and 1891, Johnson reported that there was something lacking in Dow's spirit that eluded definition (figs. 14 and 15) (Johnson 1934, 54). As time passed Dow became convinced that neither he nor the Boston region artists were great painters, let alone American painters.

12

HENRY R. KENYON IN GOULDS CREEK,

IPSWICH

Albumen print, 1895

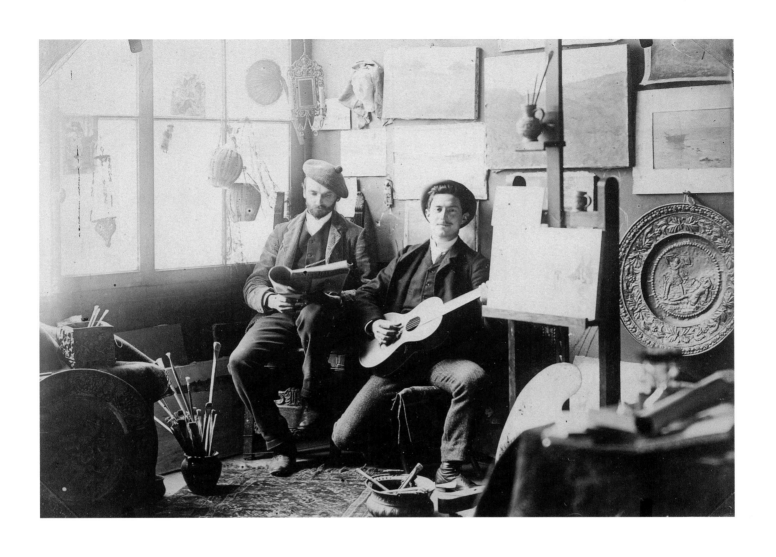

13

ARTHUR WESLEY DOW WITH

HENRY KENYON IN STUDIO, IPSWICH

Albumen print

ca. 1890

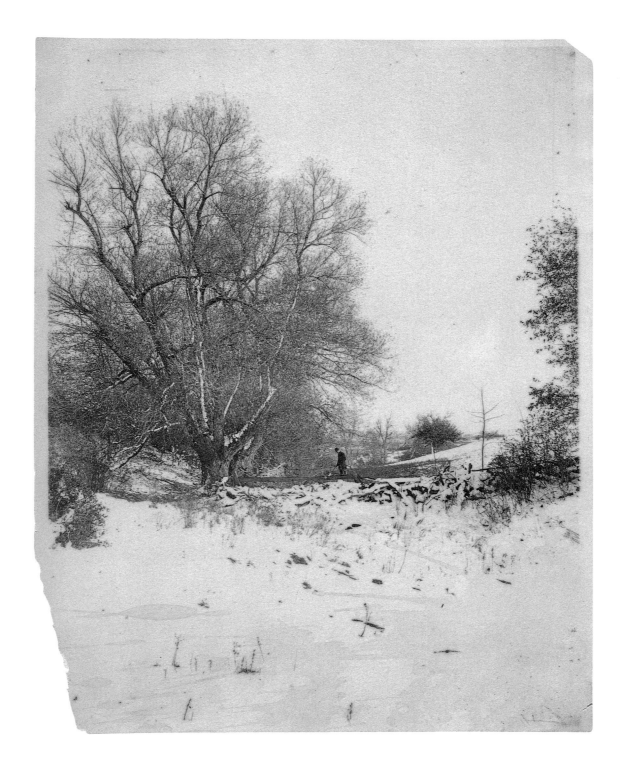

14

JO ROSS MEADOWS,

DANA IN DISTANCE, IPSWICH

Platinum, ca. 1900

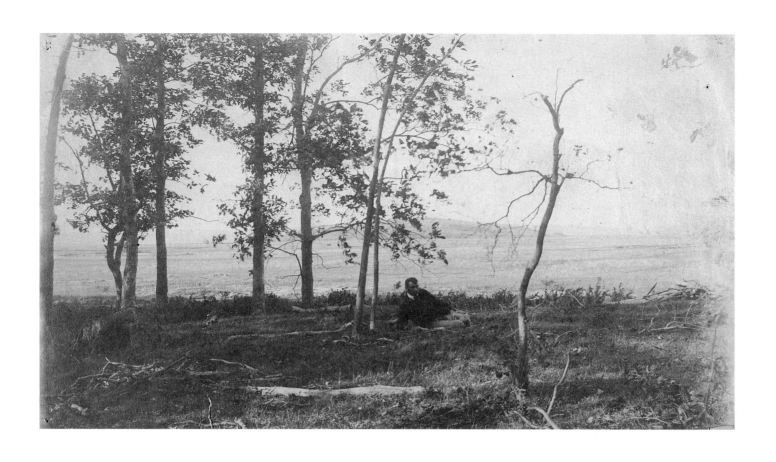

15
ARTHUR WESLEY DOW RECLINING

IN LANDSCAPE, IPSWICH

(Assisted by Dana Dow)

Platinum, ca. 1900

The personal depression that followed was relieved with his rediscovery of the graphic potential of Japanese art that he had first come into contact with at Pont-Aven in connection with the work of Gauguin and the Nabis. Johnson and subsequent historians have characterized Dow's epiphany in discovering reproductions of Hokusai woodblocks at the Boston Public Library as the catalyst for the unique contribution of his future paintings and prints and to the Arts and Crafts movement and to his book *Composition*. Clearly, that time was pivotal for refocusing on his life's challenges, for absorbing his experiences in Brittany, and for reassessing his future as an artist.

His new clarity was dramatically reinforced when he collaborated with Ernest F. Fenollosa, the curator of Japanese art at the Boston Museum of Fine Arts, on exhibitions, lectures, and articles. Almost a decade later, Dow succeeded him for a time at the museum before moving on to Columbia University. From 1891 to 1900, Dow published numerous articles, gave lectures about the new synthesis of Japanese principles in his work and teachings, infused his teaching at Pratt (1895–1903) with his evolving views on aesthetics, and traveled to Europe to augment his knowledge of Western painting—but now in the context of a broader universalism. Later, Stieglitz and other pictorialists at the peak of their style in 1908, those acquainted with Dow's theories and works, including his photographs, were especially receptive to *Japonisme*. Like Dow, Stieglitz also acknowledged the importance of the Japanese print when, in the last of the season's exhibitions at "291" in 1908, he included Japanese prints from a private collection (Peterson 1992, 205).

It was during this fertile period of reinvention of his life as artist and teacher that Dow began to explore photography as an artistic medium. Having distanced himself from the mainstream painting world, which he was convinced was beyond reach, he began a productive period of working in alternative media and methods. He continued to paint but in a style that reflected his new visual language. The fact that this work was not accepted immediately only underscored its revolutionary nature at the forefront of future developments in the arts. Further, this new work could not be separated from the artist's teaching and from other activities. He was now delivering the gospel by example and by teaching his beliefs. However, despite the fact that it reflected new aesthetic directions, Dow's works in all media also mirrored timeless concepts—the elusive nature of beauty and the structures by which it can be expressed (figs. 16 and 17).

1. Max Weber oral history interview, Columbia University, 1958. Special thanks to Julie Weber for drawing these comments by her father about Dow to my attention.

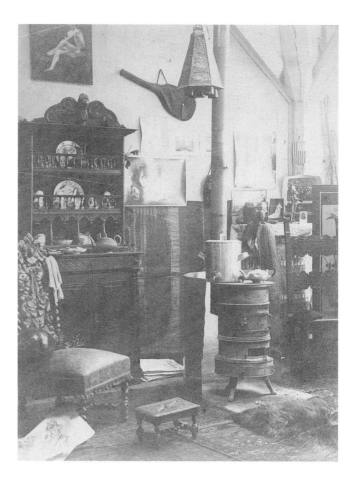

16

DOW STUDIO WITH STOVE, IPSWICH

Albumen print, ca. 1890

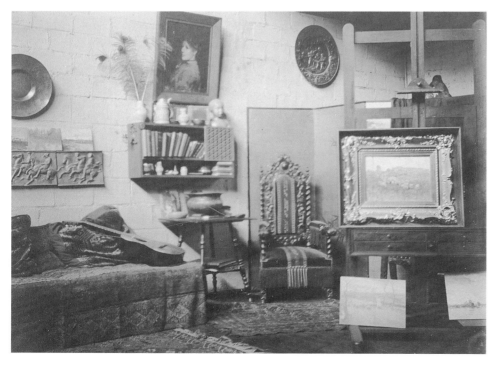

17

DOW'S BAYBERRY STUDIO,
IPSWICH

Silver print, ca. 1902

18

CLAM HOUSE, IPSWICH

Block print, ca. 1892

To FULLY APPRECIATE Dow's GIFT for working in a variety of artistic media, especially photography, it is important to trace the roots of influence and knowledge that provided continuity in his work and persuaded him of photography's potential as an art form. As aesthetic issues are somewhat like tree roots that gradually reach down into the soil of one's life, a discussion of Dow's aesthetics in general cannot be separated from his life and times.

Understanding the Victorian era is the basis for comprehending the milieu in which Dow lived and worked. Regarding general influences of the era, Dow admired James Abbott McNeill Whistler, John Ruskin, Henry David Thoreau, and Ralph Waldo Emerson and read extensively the works of classical authors of philosophy, poetry, and theology—all common influences on artists and intellectuals of the time. Even Japanese elements of design and composition that fascinated Dow were present in Whistler's work long before Dow embraced them. Because the work of Whistler represented the avant-garde or at least a break with traditional academicism in art, it undoubtedly had considerable impact on Dow at the formative stage when he realized he would have to study in Europe to become a recognized painter.

In addition, various more specific events, individuals, and ideas reveal important relationships between Dow's photographs and other works of art. Following Dow's first years at the Académie Julian, he spent the summers of 1885 and 1886 in Pont-Aven, where he came into contact with Gauguin and devotees of his so-called *Nabis*, a group of painters devoted to flat, color-rich, decorative subjects divided into patterned compositions. The Nabis were in their formative stages during Dow's time there but were, nevertheless, part of the avant-garde, promoting modernist ideas and rejecting impressionism in favor of decorative abstraction. They were called the Nabis, a word derived from the Hebrew *Nebiim*, which means prophet, because many of their paintings included religious subjects. In fact, the entire Pont-Aven region encompassed a deeply religious (Catholic) community. The inclusion of religion in discussions and art must have been inspiring to Dow, who had struggled to find common ground for his own religious and aesthetic beliefs.

Gauguin was to have a dramatic and lasting impact on Dow's aesthetics, especially in regard to his relationship to modernism and the avant-garde. In the beginning it was a negative influence, but in the end many of Gauguin's ideas about color, line, and form became core elements of Dow's own aesthetic thought and process. Despite similarities of thought, however, their characters differed considerably. Gentle and intellectual, Dow was apparently the antithesis of Gauguin, who had a commanding presence and was notoriously aggressive. A. S. Hartrick, one of the many academic artists in Pont-Aven, described Gauguin as "tall, dark-haired and swarthy of skin, heavy of eyelid and with handsome features, all combined with a powerful figure, Gauguin was indeed a fine figure of a man. . . . In manner he was self-contained and confident, silent and almost dour, though he could unbend and be quite charming when he liked" (Sutton 1966, 5). Extremely physical, Gauguin was a boxer, sharp-tongued, and sometimes got involved in fights. Still preoccupied with Gauguin's arrogance on his return to Ipswich, Dow confided to his best friend, Henry Kenyon, fellow American at the Académie Julian, "When I hear of Gauguin I can see him thumbing his nose at Otto Wigand and me. I can't see anything in his work or Van Gogh's that isn't in the most ordinary Japanese print" (Green 1999, 16). Yet, despite his protestations and his own resolve to remain a landscape painter who was neither academic nor impressionistic, as he felt Gauguin and Van Gogh were, Dow often listened to Gauguin hold court in the tavern of the Pension Gloanec, where all the painters stayed.

Critical to Dow's development was the concept of "synthesis," which Gauguin stressed in every discussion of aesthetics and which to him involved the synthesis of form and color derived from the dominant element of a composition. Importantly, Dow later used the word *Synthesism,* in the original Greek, on the title page of *Composition,* which had as its central theme the use of "line, notan, and color," concepts clearly cut from the same aesthetic cloth as Gauguin's "line, color, and form."

Numerous examples from Gauguin's paintings and reported discussions on aesthetics at Pont-Aven make it clear that Japanese art, including the prints of Hokusai, was a guiding influence on the evolution of Gauguin's style and aesthetic philosophy (Sutton 1966, 8). According to Johnson, in 1890 Dow claimed that upon seeing reproductions of Hokusai's work at the Boston Public Library for the first time he understood something about composition and being a painter that had previously escaped him (Johnson 1934, 54). Although he had until this moment held Whistler up as the grand model for all painters, he now denounced him for copying the Japanese, in spite of his own genius. Since Dow was usually generous to a fault, he may have meant this more along the lines of something that Pasteur reportedly said, "Genius borrows nobly."

Regarding the influence of Japanese aesthetics on Gauguin, Denys Sutton states: "The most striking alterations which were then taking place in his approach to painting may be discerned in the *Two Bathing Boys . . .* and in the *Two Fighting Boys,* . . . painted before July of that year (1887). The second picture, as he [Gauguin] said, was executed in 'an altogether Japanese style . . .

very sketchily done' and painted. . . . The artist's receptivity to fresh experiences made him particularly responsive to Japanese prints, and his appreciation of such works, which were very much *à la mode* in France, undoubtedly assisted in the development of his decorative style" (Sutton 1966, 7).

A further example of the influence of Gauguin and his followers, including Paul Sérusier and Emile Bernard, on Dow involved the use of flat masses of color in his painting and prints. At Pont-Aven, Gauguin and the Nabis moved away from impressionism and cloisonnisme and focused instead on simplification of the picture plane characterized by large flat areas of paint separated by masses of abstract color. This technique very closely describes Dow's later application of color separated by masses of shape and tone or dark and light (notan).

Some artists at Pont-Aven were, however, outraged by Gauguin's aesthetics. Sutton quotes Sérusier as saying, "Their paintings so enraged some of the other, and more conventionally minded, artists staying in the pension, that one of them, the seventy-year-old Gustave De Maupassant . . . threatened to walk out of the hotel if any of Gauguin's pictures were hung up in the dining-room" (Sutton 1966, 6). Further, Sutton describes the significance of these aesthetic views of Gauguin during the period of Dow's residence in Pont-Aven: "The reflection of this taste [Gauguin's] is especially well shown in his *La Vague* of 1888 (now lost), which seems to be directly inspired by a Hiroshige print. Above all, he was starting to emphasize the expression of emotional content. It was a trend which had been already announced, however prematurely as far as his own painting was then concerned, in his well-known letter of 1885 to Schuffenecker. This had revealed his attraction to the idea of a poetical and synthetical style and this position was further affirmed in the notes on synthetism jotted down in his Carnet of 1886" (Sutton 1966, 7).

Yet despite debates about such modernist principles among artists at Pont-Aven, the modernist ideas suggesting that painting could create its own reality were to become a significant aspect of Dow's teaching philosophy.

Two other artists—Jean-François Millet and Puvis de Chavannes—also linked Dow and Gauguin, leaving little doubt that the tenets of modernism affected Dow. When Dow was studying at the Académie Julian, before his first trip to Pont-Aven, he reported in letters sent to Ipswich (Johnson 1934, 34) that he also had enrolled in the École Nationale des Arts Decoratifs, where Jean-François Millet critiqued students' works, giving them considerable individual attention. Dow recalled this experience as the "richest" of his time in Paris. Gauguin is also known to have been influenced by the peasant paintings and drawings of Millet and wrote about Millet's art in his 1889 *Le Moderniste* (Sutton 1966, 7).

Additionally, Puvis de Chavannes influenced Gauguin at this time, according to Armand Séguin, who claimed that Gauguin's room at Pont-Aven contained reproductions of the work of Puvis de Chavannes, among other artists. Moreover, Gauguin's closest friend at Pont-Aven, Emile Bernard, had said on meeting Gauguin that perhaps there was too much of Puvis de Chavannes in Gauguin's work (Sutton 1966, 6). In 1892, Dow and his mentor, Fenollosa, were responsible for

helping Puvis de Chavannes obtain a commission in that city. When the critical art world of Boston repudiated the French painter's work, Dow came to his defense in the columns of the *Boston Transcript* (Johnson 1934, 59–60).

Further influences on Dow and the Pont-Aven artists were two general tendencies of the art world at the time—the prevalences of poetic statements about the nature of painting itself as distinct from statements on nature or reality, and a broad-based belief in the relatedness of various art forms, especially music, poetry, and painting. Noteworthy in this context is the fact that when Stieglitz showed his photographs to Ernst Bloch, the composer said his work was music. Similarly, in 1903, when Dow was on a year-long trip around the world and visited the Taj Mahal, he recorded in his diary that the long time he spent at dusk viewing the great architectural wonder ". . . was like listening to great music" (Johnson 1934, 82). An even more elaborate statement by Dow that apparently includes photography and crafts among the "new arts" in the twentieth century and stresses the importance of a common aesthetic was included in his notebook of ideas about art:

> With the beginning of the present century representation began to take on a new meaning. The new arts must be ranked as Fine Arts, but their representation must be determined by use, nature of material, and the laws of beauty of line and colour. Here then are arts akin to painting on the side of their representation, but akin to music on their side of form. . . . The notion of painting itself has begun to split up and fall to pieces. Even in a picture, the most oily of oil paintings, there seem to be two things involved, the representative element of the subject, and the formal element, or the laws of beautiful line, notan, and colour. Now the former of these might be ranked with poetry, but there can be no question that the latter must be ranked with music. It is not intellectual, but sensuous; and yet it is the vehicle of transcendent creation and mysterious beauty, as is the sound of music" (Johnson 1934, 107).

Maurice Denis, who helped to establish the school of painting known as the Nabis around 1890, was influenced by the same modernist ideas that affected Dow. Also like Dow, he developed a style and theory that helped usher in a true sense of modernism. In the May 1909 issue of *L'Occident*, Denis wrote about the ferment of Pont-Aven, Gauguin, and the rebellious ideas that set the artists there free from academic teaching, painting, and general convention (Denis 1982, 51–53). Moreover, in his essay "From Gauguin to Van Gogh to Classicism," he summed up the nature of art at the end of the nineteenth century and the refinements that heralded the beginning of the next:

> No doubt there had been preparations for the new wave of 1890. . . . Everything has been said on this subject: the absence of all rules, the ineptitude of aca-

demic teaching, the triumph of naturalism and the influence of Japanese art had caused the joyous birth of an art which appeared to be free from all constraint. The new motifs of sunlight, artificial lighting and the whole picturesqueness of modern life had been admitted to the domain of art. Literature was combining the vulgarities of a waning realism with the refinements of symbolism; "the slice of life" was served up raw; at the same time in poetry the lyricism of young writers was being tried to the limit by the elitist love of the rare word, the novel state of mind, and obscurity. . . . Everywhere new ideas were fermenting. . . . It was the excess of this anarchy which brought about, as a reaction, the desire for system and the taste of theories (Denis 1982, 51–52).

When Dow returned to Ipswich in 1889 and began assessing his Pont-Aven experience, he discovered an aesthetic theory and system that aided his understanding of it. The result was his book *Composition*, which represented his unique adaptation of the Pont-Aven school theories.

The characteristics of Dow's work that evolved during his time in France between 1885 and 1889, including more skillful draftsmanship, were absorbed by his new style after 1890, when he made a dramatic conversion to flat-color compositions, especially in woodblock prints. This later work, inspired by his adaption of Japanese aesthetic principles and the Pont-Aven experience, reflected greater abstraction of reality and a search for the spirit of place. Also in 1890 he began to explore photography for its own sake, because its graphic qualities were compatible with his new theories (figs. 18, 19, 20). Before that time, in 1885, he produced in the region of Pont-Aven a series of drawings and sketches

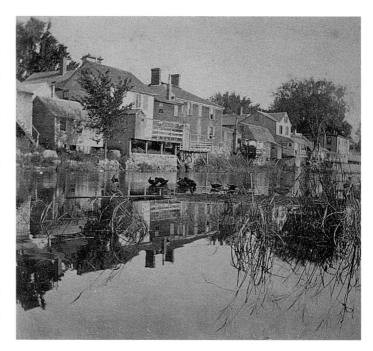

19

LITTLE VENICE, IPSWICH, MASS

Silver print

Album, pg 25

ca. 1900

that represents a link to his past in Ipswich (figs. 21, 22, 23). However, these works are both more sophisticated than those made prior to his study at the Académie Julian and more spontaneous, reflecting a direct emotional response to subjects rarely found in his more finished works. The sense

41

20

IPSWICH POLE HOUSE ON WATER

Cyanotype, ca. 1890

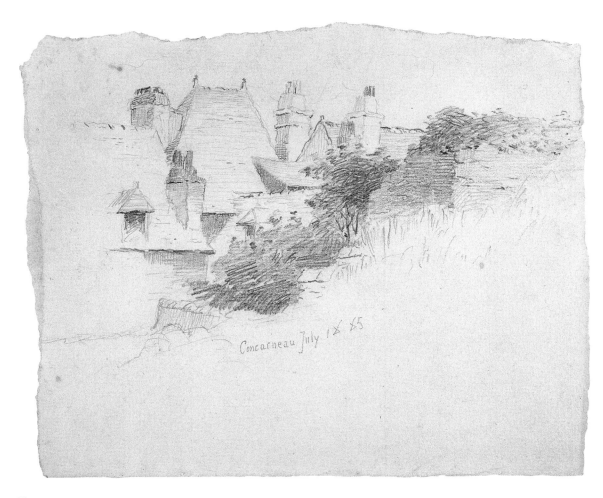

21

CONCARNEAU

Pencil drawing, July 18, 1885

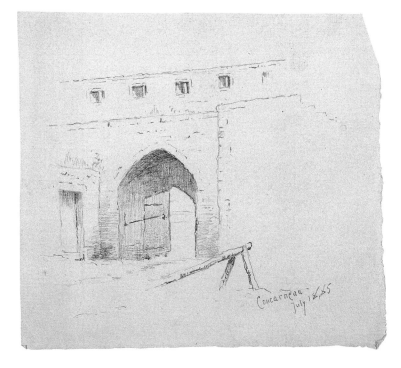

22

CONCARNEAU, STONE GATE

Pencil drawing, July 18, 1885

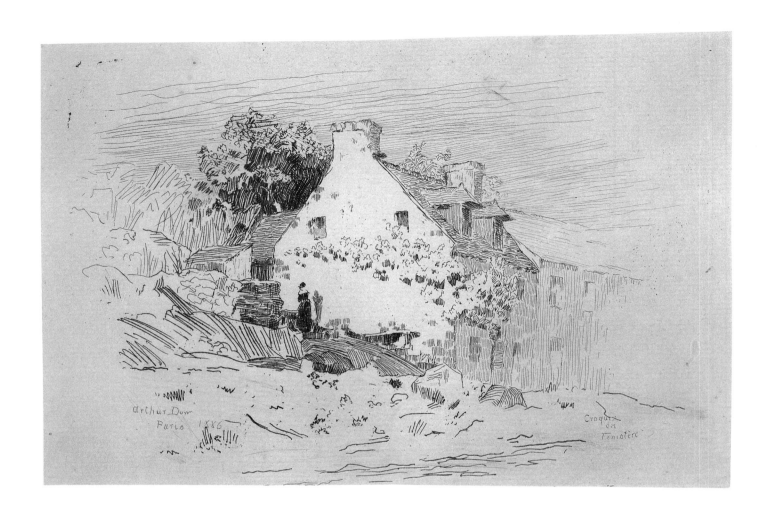

23

CROQUIS EN FINISTÈRE

Ink drawing, 1886

of immediacy in these drawings is similar to visual qualities found in his photographs, as can be seen by comparing his only known surviving photograph from Pont-Aven, of a cemetery, with one of these drawings made at the same time.

There can be little doubt that, like his drawings, the photographs Dow made at this time were sketches, not exhibiting the conscious effort to explore the medium aesthetically that can be seen in photographs after 1890. Since Dow was somewhat resistant to the topics being discussed by Gauguin and others at Pont-Aven, he would not have yet seen photography in the context of the universal relatedness of aesthetics ideas influencing him at the time. But just as there is an eloquent use of line and texture in Dow's drawings, so his photograph of the cemetery shows sensitivity to line and texture in the shadows of the fence and the contrasting light surrounding three crosses (figs. 24, 25).

Since Dow's sense of aesthetics, throughout his life, was a mixture of modernist ideas about form and pictorial idealism, consequently his photography also reflects these characteristics. Initially, he used the cyanotype process like a sketch to aid his visual recall of specific times and places. However, as his interest in photography grew, he often made cyanotype images as finished images while continuing to use the process simultaneously for documentation. It is only when his photographs reflect a conscious effort to compose or to produce a purely photographic statement that the photographs are more than documents. This issue of Dow's use of photography as source material for other media, such as his paintings, is no longer relevant in later years when he explores a variety of more sophisticated photographic processes, such as platinum or gum bichromate prints, and the surviving images clearly represent finished works (figs. 26, 27). The cyanotype, which was developed in the 1840s by Sir John Herschel, was used by some photographers in Dow's time much as Polaroid print materials are used today—sometimes as a study before making a final negative and other times as the finished artwork.

It is to be expected that Dow's early style of drawing, which was elegant and linear during his time at Pont-Aven, would have later evolved due to the influences of Japanese and modernist art after his return to Ipswich. However, a surviving sketchbook from 1919, containing twenty-seven sketches of desert landscapes in colored pencil and tempera, reveals a desire at the end of his life to reclaim the visual spontaneity that he experienced at the beginning of his career. Dow and Minnie made trips to the Grand Canyon in 1911, 1912, and with a side trip to California, in 1919. The sketchbook was made on the trip to California and the delicacy of these drawings recalls the 1885 drawings from Pont-Aven (figs. 28 and 29, 30 and 31). Both these drawings and his photographs reflect a more spontaneous approach, in contrast to his woodblocks and paintings from the same period. In general, Dow's strong attachment to the sensual character of line and the emotional qualities of landscape are artistic characteristics that span his entire career, providing aesthetic continuity throughout his work, especially in his drawings, prints, and photographs.

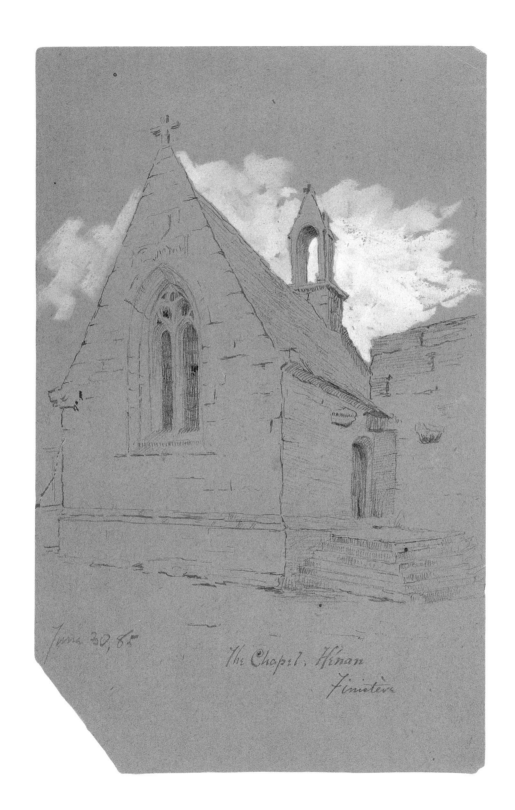

June 30, 85

The Chapel, Hénan
Finistère

24

THE CHAPEL, FINISTÈRE

Pencil and tempera drawing, June 30, 1885

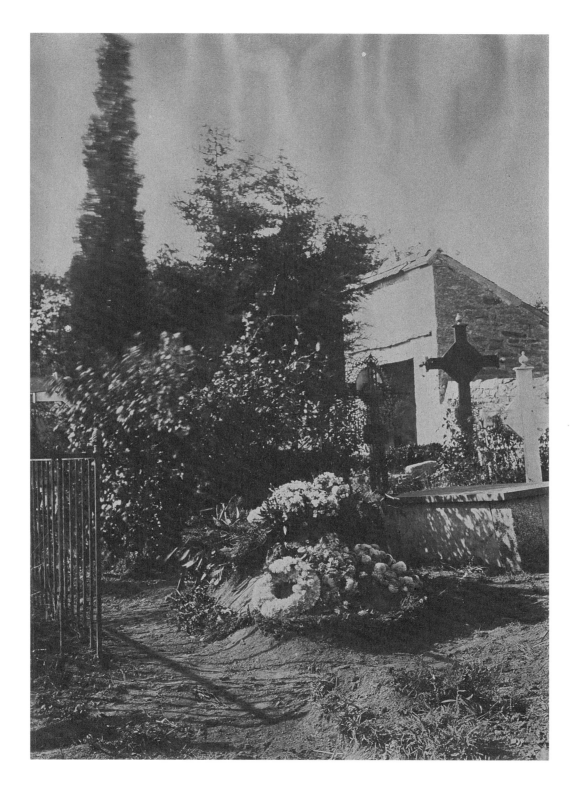

25

CEMETERY AT PONT-AVEN

Cyanotype, ca. 1885

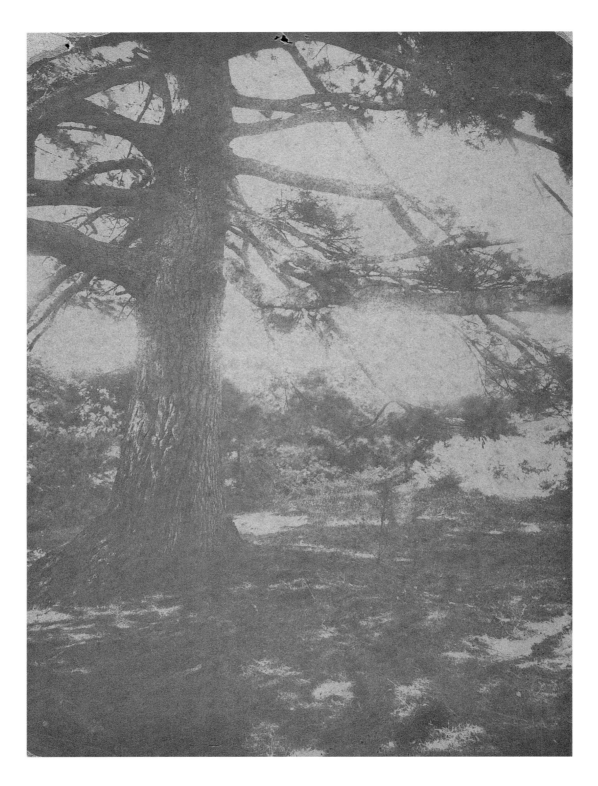

26

PINE TREE

Platinum, ca. 1900

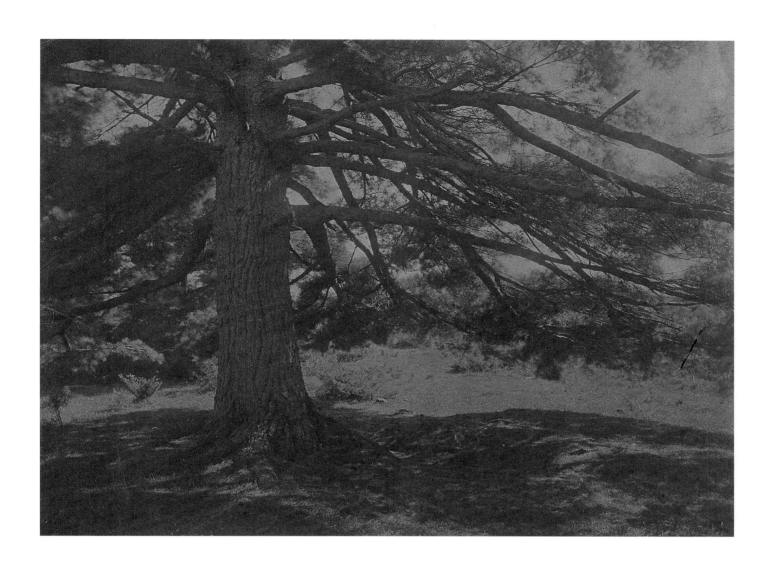

27

PINE TREE

Cyanotype, ca. 1895

28

ROCK AND SAGE

Colored pencil, 1919

29

SACRED WELL, PONT-AVEN

Pencil drawing, ca. 1885

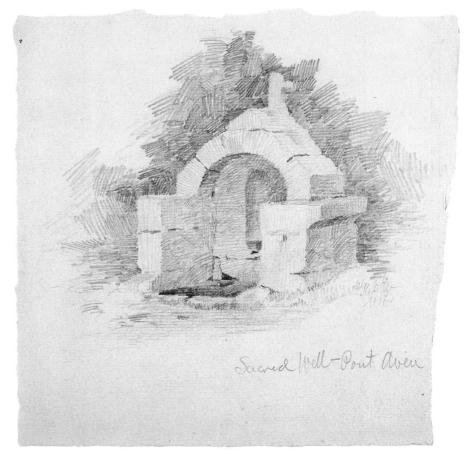

Sacred Well—Pont Aven

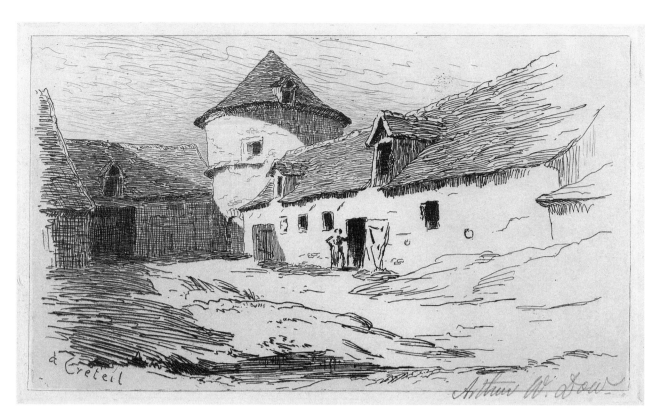

30

À CRETEIL

Etching, ca. 1885

31

CLOUD SHADOWS ON THE

SAND MOUNTAINS

Colored pencil and tempera, April 26, 1919

A prime example of the extent to which Dow's vision and his aesthetic philosophy remained the same, regardless of various theories he espoused, can be seen in an albumen photograph of his first salon painting (1885, exhibited in 1887) and a photograph he made of a strikingly similar subject in Ipswich in 1902. The comparison between the painting of two trees in a meadow in Brittany and the photograph also provides an interesting reversal of the usual presumed relationship between photography and painting in the nineteenth century. Here the photograph was not the source for the painting but, instead, the painting was made first, although the subject of this painting clearly remained in Dow's visual memory when, two decades later, he made the delicate platinum print of two trees in an Ipswich meadow (figs. 32, 33).

As Dow's photographic sophistication grew, both technically and visually, the continuity between his woodblock prints and his photographs became more apparent. In pursuing the massing of light and dark, or notan, whether in color or monochrome, he often produced works that were extremely similar in content and style. For example, in 1895, after he had begun to master woodblock printing, he made a flat-toned, color woodblock print of another Ipswich landscape with trees and an elevated horizon reminiscent of the early salon painting. Moreover, in 1902, Dow

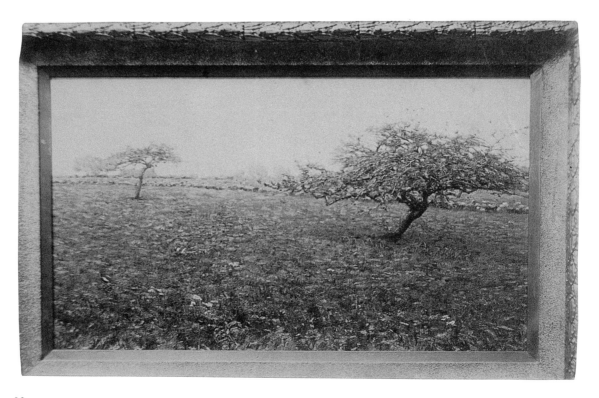

32

PHOTOGRAPH OF DOW'S FIRST SALON

PAINTING, TWO TREES, IPSWICH

Albumen, ca. 1886

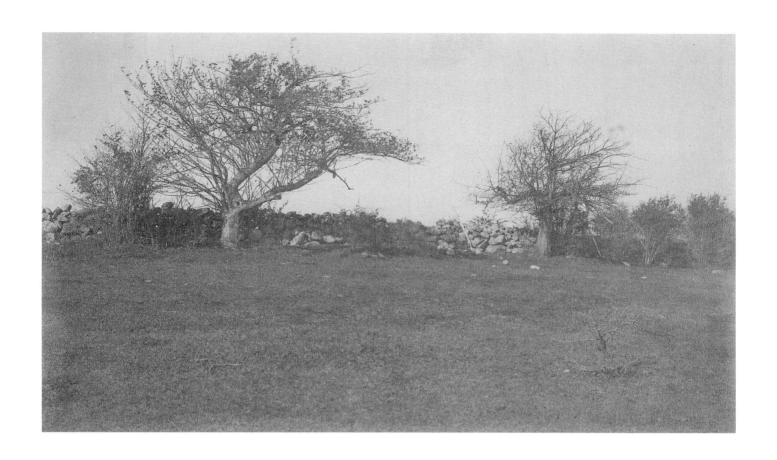

TWO TREES, IPSWICH

Platinum, ca. 1902

34

MEADOW WITH TREES

Block print, ca. 1895

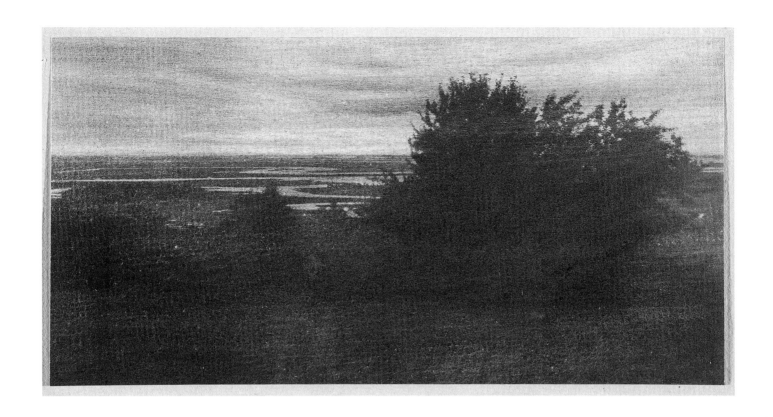

35

THE DRAGON

Gum bichromate print, ca. 1902

took a photograph that aesthetically and structurally repeated the composition of the woodblock print. This time the photograph was produced by the then popular gum bichromate process, a process that combined gum arabic, pigment, and potassium-bichromate and permitted the printing of photographs on handmade or watercolor paper so the image resembled a pastel drawing. The process also allowed for great tonal manipulation of light effects and mass, with the result that a print would often lack any resemblance to the original negative. The massing of dark and light tones, characteristic of the pictorialist photographers of the Photo-Secession and subsequent movements, produced a romantic effect that appealed to Dow, and the few photographs he made in this medium have an elegant tactile quality. Further, the deep umbers and brown tones characteristic of gum bichromate prints belonged to a color palette Dow often used in other media, including painting.

The earth colors used in many of Dow's photographs are reminiscent of the works of Millet, whom he met in Paris and greatly admired. Interestingly, among photographers of the time Dow was not alone in his admiration for Millet. In the early 1890s, Alfred Stieglitz's photographs of the Netherlands depicted Millet-like genre scenes. Such romanticized, pastoral scenes were also typical of the Arts and Crafts movement's belief in the dignity of human labor and the spiritual qualities of nature (Peterson 1992, 183). As we have seen, Gauguin was also influenced by the peasant paintings and drawings of Millet.

Between 1885 and 1911, Dow's photography evolved along with his clarity about his modernist philosophy. In painting, his sense of modernism was a curious mixture of rejecting traditional, academic styles and proclaiming the virtues of abstraction—but not at the expense of form. The use of color in his paintings of the Grand Canyon reveals the influence of the French Fauves, while the brushwork is typical of his friend Maurice Prendergast and the new realist painters, such as Robert Henri. Frederick C. Moffatt, who wrote the first major study of Dow and the modern influences on his painting, said that the Grand Canyon paintings were ". . . in essence a demonstration that he was capable of taking on some of the most radical elements of contemporary art without giving up the essential principles of composition" (Moffatt 1977, 117). In referring to the same paintings, which were exhibited at the Montross Gallery in 1913, Johnson wrote that ". . . Dow stated quite frankly that in the work which he had done he had not attempted to paint particular places, nor any of the famous views of the Canyon, but rather he had sought to abstract the spirit of the place" (Johnson 1934, 99). This latter statement is central to the works that were produced by artists connected with Stieglitz's "291," as well as formalist works created by later photographers, such as Edward Weston and Paul Strand.

The very abstract nature of some of Dow's paintings, and most clearly of his photographs, is evident in a 1911 photograph and a 1913 painting (figs. 36, 37). Both works utilize exactly the same abstraction of the horizon line, in which the top edge of the bluff and the horizon merge into one straight element. In addition, the photograph departs radically from the photographic pictori-

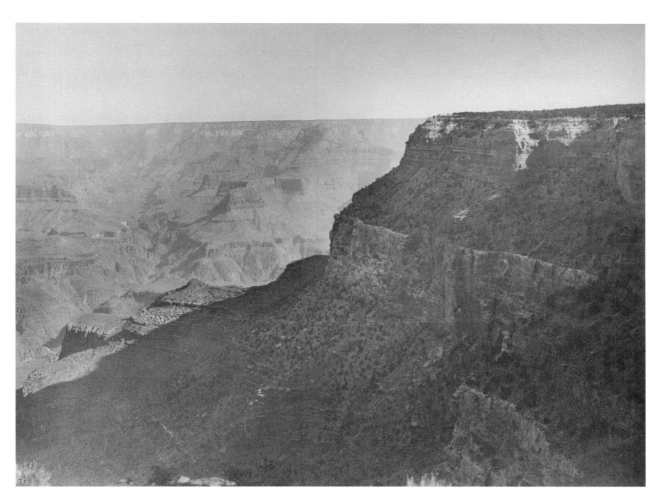

36

GRAND CANYON, GREAT BLUFF

Toned silver print, 1911

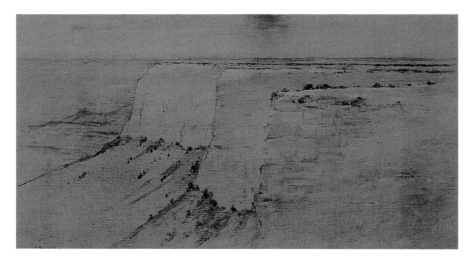

37

GRAND CANYON, REPRODUCTION
OF DOW PAINTING "LONG BEAMS
OF LIGHT ON THE FOREST,
GRAND CANYON, ARIZONA"

Albumen print of painting by
Fred W. King, ca. 1913

alist works of the time by flattening the bluff itself into a triangular shape with its front edge slicing diagonally across the picture plane. In fact, this photograph exhibits a much more advanced approach to modernist ideas than any of Dow's paintings of the period, which still reflected romantic qualities.

The two works have numerous roots. The foremost influence on Dow's photography is the work of Alvin Langdon Coburn, a student at his Ipswich summer school in 1902 and 1903. Coburn brought Dow one step closer to what was occurring on the international scene in terms of pictorialist subject matter, which in America had been tied to narrative and classical imitation of painting. As Stieglitz, Gertrude Käsebier, Clarence White, and Coburn began to proclaim a unique aesthetic potential for photography, they did so by combining romantic subject matter with structural and formal characteristics of modernism (figs. 39 and 40). Eventually, Käsebier, White, and Coburn all broke with Stieglitz because of his dictatorial manner and his rejection of teaching and applied uses of photography. Dow was, of course, in their camp and would not have warmed to Stieglitz in any case, since his autocratic, arrogant manner Dow had already rejected in the person of Gauguin.

38

SOUTHWEST DESIGNS

Cyanotype, 1899

Dow's adaption of oriental design elements in his art and especially in the production of works to illustrate his pedagogic theories in *Composition* contributed to a broadening of the modernist aesthetic in the Arts and Crafts movement, notwithstanding the primary influence of Art Nouveau. No influence on individuals or movements is static but interacts with other elements to create new styles and movements. This concept applied to Dow's photography, as can be seen by comparing a series of works made between 1899 and 1911 (figs. 38, 41, 42, 43).

Graphic, abstract elements can also be seen in photographs Dow made on his trip around the world in 1903–4, especially in works of India, which anticipate the dramatic modernist photographs of the Grand Canyon. When these works are viewed in association with a cyanotype of linear design, such as

39

Clarence White

ARTHUR WESLEY DOW

Platinum, ca. 1905

Collection of Roy Pedersen

40

Gertrude Käsebier

PORTRAIT OF DOW

Platinum, ca. 1896–98

41

REFLECTING POOL, INDIA

Silver print, ca. 1903

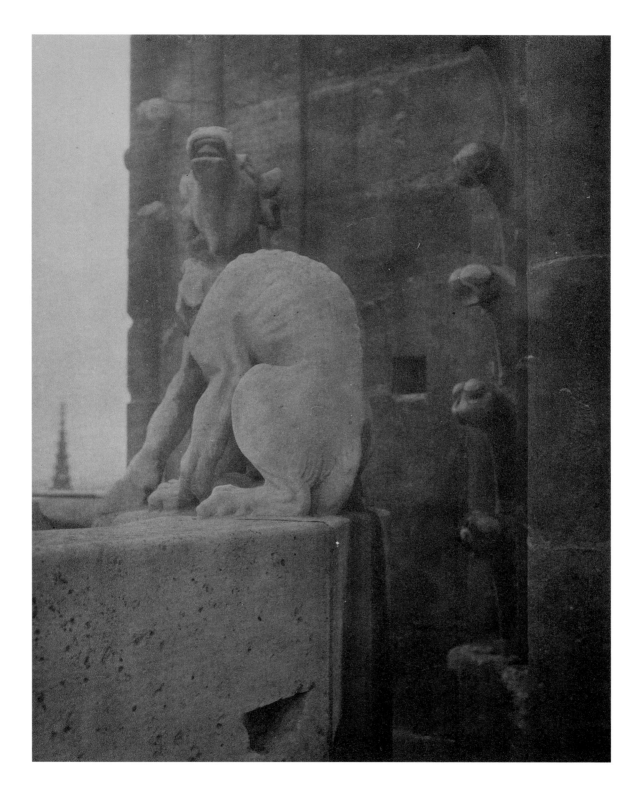

42

GARGOYLE, PARIS

Silver print, ca. 1904

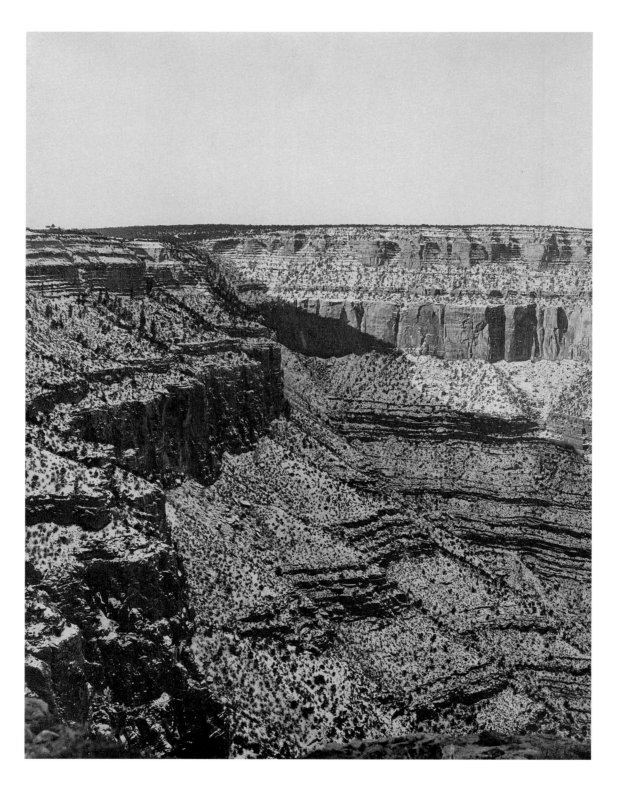

43

GRAND CANYON, WINTER

Silver print, 1912

44

Alvin Langdon Coburn

GRAND CANYON, TWO FIGURES

Platinum, 1911

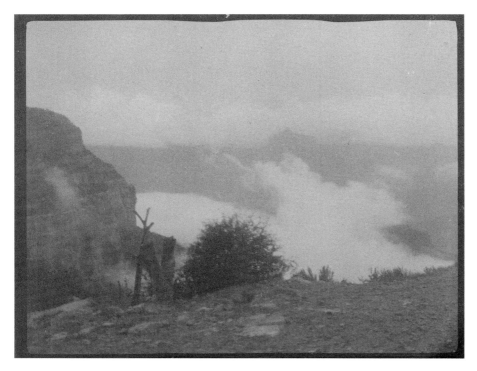

45

Alvin Langdon Coburn

GRAND CANYON WITH BUSH

Platinum, 1911

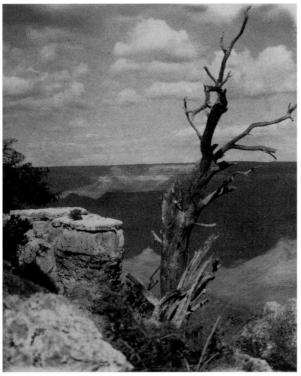

47

Alvin Langdon Coburn

GRAND CANYON, SILHOUETTE OF TREES

Platinum, 1911

46

Alvin Langdon Coburn

GRAND CANYON WITH DEAD TREE

Platinum, 1911

those illustrating *Composition*, the continuity among his various aesthetic interests becomes apparent. Further, in photographs he took in Paris of Notre Dame's gargoyles, the romantic subject matter remained secondary to a highly geometric arrangement of shapes—again anticipating the images made at the Grand Canyon. Although these photographs from his world tour were not widely seen at the time, they were exhibited along with his paintings and woodblocks at the Montross Gallery in New York in 1908. New York art photographers, even then, would have been aware of the show, especially Clarence White, since this was the year that he began teaching photography for Dow at Columbia Teachers College.

One of the most specific statements that Dow made about photography as an art form and its potential for expressing the essence of a subject was reported in a Los Angeles newspaper on the occasion of his lecture in 1911 to an art club, which was also showing a selection of Coburn's photographs, including portraits. Commenting on photography in general, but with implied references to Coburn's work, Dow said, "It's a bad photograph that tells too much . . . the real artist wants to bring out only that which is finest in the features and expresses the best emotions. And yet, some

64

people insist that artistic photography is all wrong—that it should be absolutely exact—not a line left out (n.p., n.d.)." Although it is unclear to whom Dow is referring in the remark, he was undoubtedly aware that the 1911 issue of *Camera Work* included impressionistic, pictorial works by Edward Steichen and Heinrich Kühn, as well as some of Stieglitz's most famous photographs of New York, including *The City of Ambition*. This work by Stieglitz still retained strong pictorialist qualities, even though the subject matter and snapshot style of others already reflected modernism. In fact, in a letter Stieglitz wrote to Heinrich Kühn in 1912 he advocated the modernist notion of abstraction that Dow had written about: "Now I find contemporary art consists of the abstract (without subject) like Picasso etc., and the photographic. The so-called photographic art whether attempted with camera or with brush is not the highest art. Just as we stand before the door of a new social era, so we stand in art too before a new medium of expression—the true medium (abstraction)" (Greenough 1998, 194).

It seems clear that throughout his career as an artist, Dow believed in the expressive potential of abstraction. Drawings, prints, and photographs alike present abstract elements, though in the context of subjects or visual qualities that evoke emotional responses.

Although not a master of the various photographic processes he used, Dow was an ardent experimenter with a keen vision of photography's artistic possibilities. Two photographs (one silver, the other platinum) reveal his interest in experimenting with the range of the medium's aesthetic potential (figs. 48, 49). One, of a mother and daughter in a garden made in 1890, is framed with foliage in a manner characteristic of much contemporary photography today that utilizes out-of-focus foreground as a prominent aspect of an image. The other, a circa 1902 image of a student using a spinning wheel at Dow's Ipswich summer school, is reminiscent of the pictorialist works produced at the American School of Photography established by Clarence White and his colleagues after they broke with Stieglitz.

Because Dow never promoted himself extensively as a photographer, even though he believed in photography ardently as an art form, he had more freedom to experiment with its potential in any context or style he wished. Later, Stieglitz and other pictorialists at the peak of their style in 1908, who were acquainted with Dow's theories and works, including his photographs, were especially receptive to *Japonisme*. Like Dow, Stieglitz also acknowledged the importance of the Japanese print when in the last of the season's exhibitions at "291" in 1908 he included Japanese prints from a private collection (Peterson 1992, 205). While he imparted to photographers he came in contact with his unique aesthetic concepts based on Japanese influences and on his experiences from Pont-Aven, he also adapted the new understanding of photography that came from such contacts. Although the word *synthesis* in connection with the arts may have been first used by others, Dow's appropriation of its meaning for modernist aesthetics is also an apt description of the way he integrated photography with other media. His decision to explore photography's potential in terms of what it could teach painting as well as what it could offer as a separate artistic medium, was a true and timely act of synthesis for the art world at large.

65

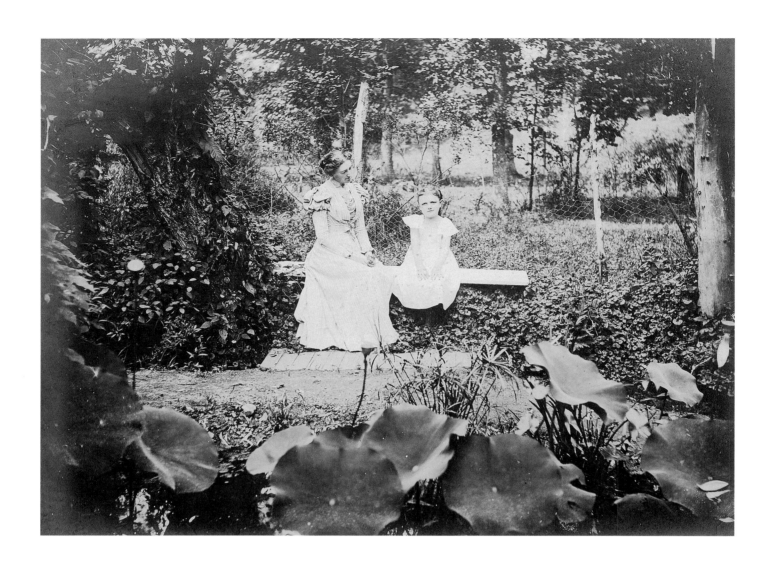

48

MOTHER AND DAUGHTER IN GARDEN, IPSWICH

Silver print, ca. 1890

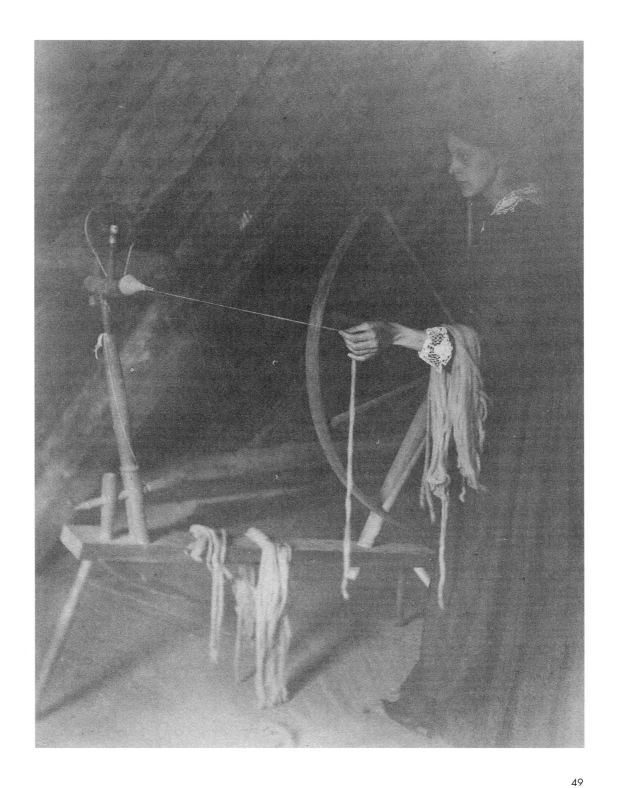

49

ALTHEA HARMER (MRS. BARDEAU)

SPINNING IN EMERSON HOUSE, IPSWICH

Platinum, ca. 1902

50

SINGLE TREE, IPSWICH

Toned silver print, ca. 1890

51

SINGLE TREE, IPSWICH

Cyanotype, ca. 1890

When Dow returned to Ipswich and reaffirmed his mission to live by his painting, he discovered that he was no longer the artist that he had intended to be. By 1890, a year after his return, he was not only questioning how his painting style had come to reflect the fashions of the day but had realized that to succeed he would need to be a part of the contemporary art scene and move to Boston. But there, too, he observed, ". . . they were all painting away, day after day, conforming to their Parisian standards, observing rules as if they were from on high, and out of all this welter of canvas and paint there were but degrees of proficiency in a deadly sameness" (Johnson 1934, 52). What he did not immediately recognize was that his experiences in Pont-Aven had seeded an understanding, if not appreciation, for the challenges inherent to modernism. One such challenge was aligning the idea of abstraction with a structured sense of design, whether found in Japanese prints or historic architecture. A greater challenge, however, was looking for a spiritual center in the essence of his subjects, a prime aesthetic of the modernist movement. This was a parallel development to his personal search for spirituality, which had broadened beyond his Puritan roots. Dow believed that spirituality and aesthetics could be harmonized in a quest for beauty, even in the works of arrogant personalities, such as Gauguin. The Pont-Aven artists of this period had enthusiastically combined religious subjects with the modernist stylistic characteristics of line, flat color, and bold geometric form. Gauguin's own venture into religious painting included his now famous *Le Christ Jaune* (1889).

However, while Gauguin and others sought to express the essence of the artist's spirit in religious subject matter, Dow never attempted to mix his spirituality with his subjects. Although his Puritan heritage was at odds with the idea of making images with religious content, this cannot account for the absence of such subjects in his work because it is known that he eventually preferred Catholic and Episcopalian churches because of the aesthetic nature of their services and visually rich iconography. Indeed, Fenollosa, the orientalist who mentored Dow, often used symbolist

69

language in speaking about developing "the aesthetic faculty in the soul" (Dow 1997, 29). Dow's search for the spirit of his subjects was instead manifested in what he considered elements of beauty. When he had finally formulated his approach to composition in the form of "notan, an element of universal beauty," he elevated the tenets of modernism (formalism, abstraction, geometry) to a style entirely his own (Dow 1997, 68). This was most apparent in his photography.

Dow's search for a modernist vision through photography was enhanced by his exchanges with the growing cadre of photographers in the Photo-Secession, including Stieglitz, Käsebier, Clarence White, Coburn, and Steichen. These photographers were, however, equally influenced by Dow's appropriation of Japanese principles of composition and design. In both his writings for *Camera Notes* and in an exhibition of his photographs in New York at the Montross Gallery, Dow provided examples of how photography might employ characteristics of Japanese prints to produce more abstract modernist works.

In an 1899 article about Käsebier's work published in *Camera Notes*, Dow expressed his conviction that photography could only be considered one of the modern arts if it achieved expression beyond its natural ability to record facts. Although he did not use the word *notan*, he described it in terms that were relative to photographs as works of art. Further, he implied that Käsebier understood certain aesthetic elements common to painting and photography that were a part of a larger vision, not one restricted by process or medium:

> There are two ways of looking at a picture—one as a record of truth, the other as a work of fine art. The first is the common, the traditional way, the way of the majority of people. By them an artist's success is measured by the accuracy of his statements, by his skill in deceiving by imitation, by the faithfulness with which he copies shape, tone, and color from nature. In this view the best photograph is the clear, sharp print, which records every detail, with the utmost minuteness.
>
> The second idea, that a picture [photograph] is a work of fine art, rests upon the thought that art exists only for the purpose of creating beauty; that a picture is not merely a record or memorandum kept for reference, but something beautiful in itself. A picture is indeed a representation of something, but when produced by a real artist it has more than representation [thirty years later, Edward Weston expressed the same idea when he spoke of the essence of the object, when a pepper is more than a pepper]. Its tones, colors, shapes, its composition and style, the power and grace of its execution, all combine to make it a work of beauty, a work of fine art.
>
> To the artist, a photograph that is perfect in every detail, that renders bare facts just as they are, is interesting as a scientific record and a value for scientific study, but it has no fine art in it. It is the work of light and chemicals, and produced by an operator, not an artist.

Mrs. Käsebier's work in portrait photography shows that she chooses the artist's point of view, that a portrait is not a mere record of facts. Being a painter herself, with experience and training, and a knowledge of what constitutes fine art, she chooses to paint her portraits with the camera and chemicals. She takes the scientific process and makes it obey the will of the artist.

. . . Mrs. Käsebier is answering the question whether the camera can be substituted for the palette. She looks for some special evidence of personality in her sitter, some line, some silhouette, some expression or movement; she searches for character and for beauty in the sitter. . . . She is not dependent upon an elaborate outfit, but gets her effects with a common tripod camera, in a plain room with ordinary light and quiet furnishings. Art always shows itself in doing much with few and simple things . . . (Dow 1899–1900, 22–23).

What Dow says about Käsebier's photography also describes his own use of the medium. The difference for Dow is that he wished to be known as a painter as well as an artist who could express himself in a variety of other media of equal status.

In an 1895 essay about woodblock prints, Dow focused on another important principle that he later employed as a means of making distinctive artworks—the principle of variation. He wrote: "A painting shows forth a single colour-idea that the artist brings out of his mind. There may be many others floating there, but they cannot all be made visible without infinite labour. With the wood blocks once cut he may seize them all—there is no limit. This is why some wood block printers will not destroy their blocks. No two prints need ever be exactly alike. The slight variations give a special personal character to each print" (Dow 1895, xvi). This statement is easily applied to Dow's photography.

Dow's earliest photographs, made as both cyanotypes and platinum prints, are prime examples of making variations with a "special character to each print" (figs. 50 and 51, 52, 53 and 54). This concept illuminates his purpose in printing the same negative in both cyanotype and another medium, such as platinum, creating very different aesthetic results. Both cyanotype papers and platinotype papers were available from manufacturers from the time Dow first became interested in photography in the 1880s. Most historians who have written about Dow's painting and mentioned his cyanotype prints have expressed confusion about whether or not the blue, monochromatic "studies" were photographic sketches for paintings and woodblocks or artworks themselves. In a few cases the cyanotypes were clearly source materials for woodblocks and sketches, but even where a relationship is apparent, there were significant differences in color, mass, and content. The majority of his cyanotypes bear a closer relationship to photographs produced by other processes than to his paintings.

A clear example of his exploration of a subject using two distinct photographic processes with two similar but different negatives are 1890 images of sand dunes near Ipswich—one in cyanotype,

71

52

FLOODED MEADOW, IPSWICH

Cyanotype, ca. 1895

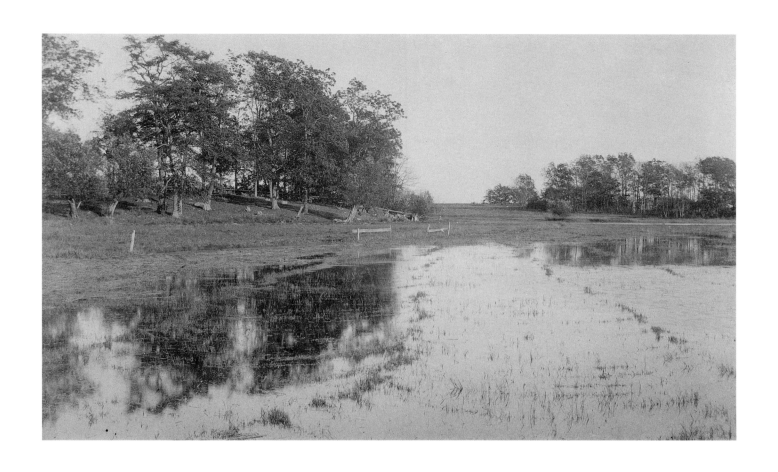

FLOODED MEADOW, IPSWICH

Platinum, ca. 1895

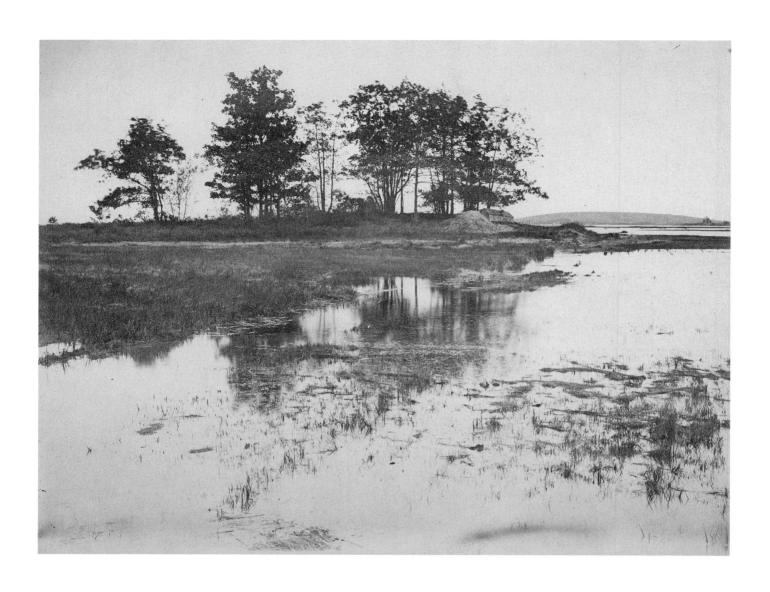

54

FLOODED MEADOW, IPSWICH

Platinum, ca. 1895

the other platinum (figs. 56, 57). While their compositions are very much alike, they make very different aesthetic statements. In the cyanotype, a path of footprints leads the eye into the composition, a device characteristic of Dow's landscapes in any medium. The print's color provides an abstraction of nature, allowing the composition and visual qualities to dominate the viewing experience. The platinum print is like a fine silver-point drawing with a delicate range of middle tones that reflect both the elegance of the process and the subtlety of Japanese prints. However, both photographs are even more about the exploration of photography's inherent visual characteristics. There is great detail in both foreground and background, yet it is subdued by the massing of delicate middle tones of gray or blue. Nature is mirrored but automatically one step removed from reality. The two images demonstrate how compositions can be repeated in images yet achieve varied aesthetic results due to the flattening of space by the lens.

Further examples of Dow's use of variation as a tool for creating unique artworks are his famous images and paintings of the Ipswich River. Titled *The Dragon* and *Bend in the River* in woodblocks and paintings from 1898 to 1910, the earliest variations on this subject were cyanotypes made in 1895 (figs. 55, 58, 59). These cyanotypes clearly influenced Alvin Langdon Coburn, who made a strikingly similar photograph in 1903 that was subsequently reproduced in the April

1904 issue of *Camera Work*. Coburn's print, also titled *The Dragon,* was made from Dow's Bayberry Hill studio when Coburn as studying at Dow's summer school in Ipswich and was produced by a combination of platinum and gum bichromate, which Dow also used in making prints at the time. In that same issue of *Camera Work,* the critic Charles Caffin wrote a review of Coburn's work in which he said: "Now the structural quality in these prints of Coburn's is partly due to the use of platinotype; to the pledge which the operator thereby imposes on himself of adhering to the facts; but that he should have thought of using the process with this intention indicates in himself a feeling for the significance of form and structure. . . . An admirable example of what I am striving to express is the print of 'The Dragon,' a view from Mr. Dow's studio, with a curious effect of serpentine lines of water winding through flat-lands" (Caffin 1997, 170–71).

55

Alvin Langdon Coburn

THE DRAGON

Reproduction print from original

ca, 1903

56

DUNES, IPSWICH

Cyanotype, ca. 1890

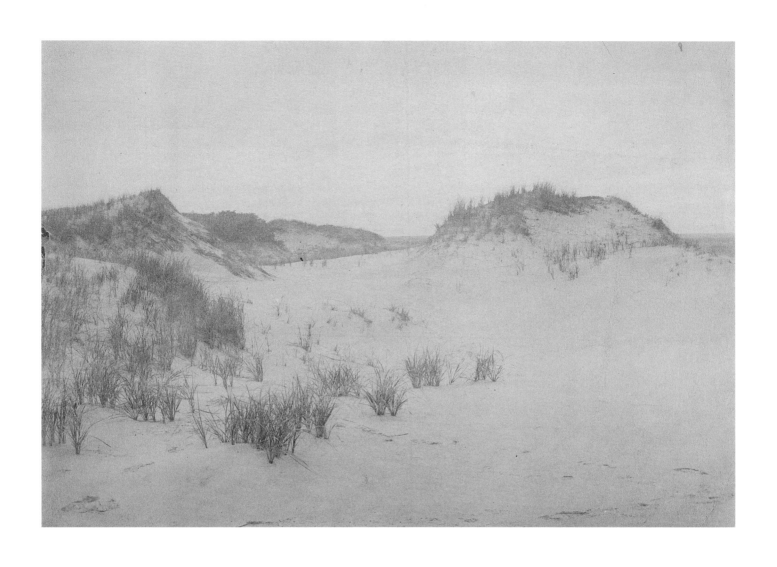

57

DUNES, IPSWICH

Platinum, ca. 1890

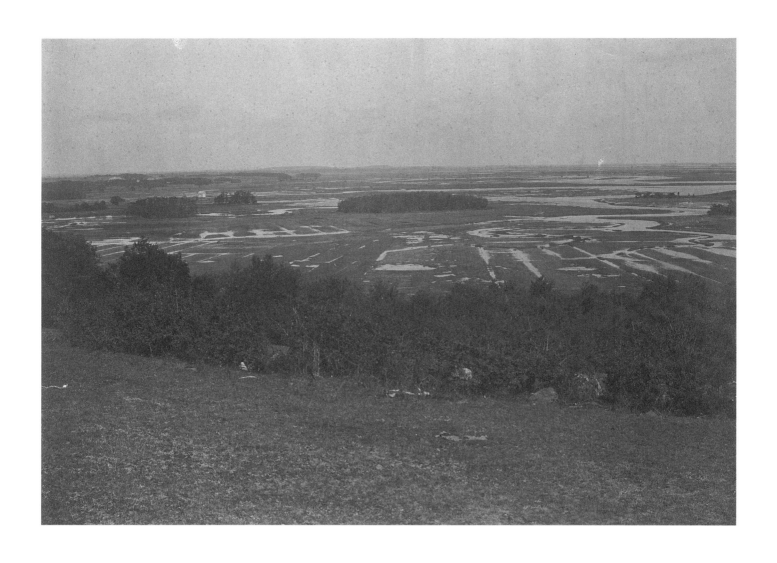

58

THE DRAGON, IPSWICH

Cyanotype, ca. 1895

59

RIVER, IPSWICH

Cyanotype, ca. 1895

Among all the photographers with whom Dow associated, he had the richest exchange and the longest friendship with Coburn. Gertrude Käsebier, who had been with Dow at the Pratt Institute, recommended to Coburn that he work with Dow in Ipswich. By that time, Coburn was already among the young avant-garde in photography, both in Europe and America. He became a member of the Photo-Secession in 1902 and a member of the Linked Ring of London in 1903. Although he had begun to develop a deep interest in spirituality before he met Dow, after studying with Dow, Coburn's fascination with the inner life took the form of a permanent appreciation of Japanese culture and Zen teachings. Subsequently, Dow was instrumental in arranging exhibitions of Coburn's photographs at the Montross Gallery, in Los Angeles, and in Tokyo.

The degree to which Dow interacted with or influenced the Photo-Secessionists is especially significant in the history of photography. Shortly before meeting Dow, Coburn had studied with Edward Steichen and Robert Demachy in Paris. In the late 1890s, Steichen had been an early pioneer in the use of platinum, gum bichromate, and combination prints using both processes. From Steichen, Coburn gained exceptional printing abilities and extensive knowledge of these media, which he shared with Dow. According to Joel Smith in his book *Edward Steichen: The Early Years*, Dow substantially influenced the Photo-Secessionists: "Three compositional points of reference among the Photo-Secessionists were Japanese wood block prints, Whistler's elemental 'nocturne' paintings, and the graphic exercises of the design instructor Arthur Wesley Dow. Like these, the best of Steichen's landscapes are defined by a taut balancing of masses within the picture's four edges, rather than by implied reference to a world beyond the frame" (Smith 1999, 23). An even more direct connection between Steichen and Dow is reflected by the fact that paintings by both were included in the same exhibition at the Montross Gallery in April 1910 (Niven 1997, 330). Since both Japanese prints and Whistler had been major influences on Dow and became significant aspects of his teaching, it would seem from Smith's observation that Dow's influence on the modernist aesthetics of the Photo-Secession may have applied to Stieglitz as well. Stieglitz was passionately dedicated to promoting photography as an art, and just as he adapted European artists' concepts of modernism so would he have absorbed Dow's influence without necessarily identifying the source. Dow was interested in modernism but not in being a spokesman for photography. Instead, he was a painter who was also fascinated with many other media of expression. His greatest influence and recognition resulted from innovative methods of teaching young artists, something that Stieglitz had no interest in. Additionally, Dow may have found Stieglitz's personality, like Gauguin's, dictatorial and arrogant, and thus their relationship may have involved a mutual exchange without camaraderie. Dow had previously operated this way, absorbing influences of the avant-garde of Pont-Aven indirectly.

By contrast, Coburn fully credited Dow's influence in his autobiography:

In 1903 I participated in the Summer School at Ipswich, Massachusetts, directed by Arthur W. Dow, later Professor of Art at Columbia University, New

York. At the Summer School we were taught painting, pottery, and wood block printing, and I also used my camera, for Dow had the vision, even at that time, to recognize the possibilities of photography as a medium of personal artistic expression. I learned many things at his school, not least an appreciation of what the Orient has to offer us in terms of simplicity and directness of composition. Oriental art influenced a photograph called "Sand Dunes" which I took at Ipswich. . . . I think that all of my work has been influenced to a large extent and beneficially by the oriental background, and I am deeply grateful to Arthur Dow for this early introduction to its mysteries (Coburn 1978, 22).

Of all the qualities Coburn and his mentor shared, including a deep religious commitment, an appreciation for the printmaking character of photography, and a strong sense of the formal aspects of modernism, none was more completely shared than their application of Japanese aesthetic principles in their photographs. The relationship of Dow's photography to Japanese influences is evident when viewing an early platinum print from about 1904 of New Rochelle, New York, together with a cyanotype he made of a Japanese screen in 1893. In both works the subjects are twisted, gnarled coniferous trees growing out of large stone boulders. Tree branches stretching across the respective foregrounds are the dominant forms of the compositions, reflecting the elegant simplicity of Japanese art despite the separation in time and culture (figs. 60, 61).

The extent to which Coburn had the modern ability to see objectively in spite of pictorial subjects, and was inspired by Japanese art, can be seen by comparing one of his photographs to an image of similar spirit by Dow (figs. 62, 63). In a photogravure by Coburn titled *Thameside Twilight* made in 1909 and a gum bichromate made by Dow in about 1902 of an isolated tree, the image qualities of the two processes and the dramatic use of notan by both artists are striking. Just as Dow's image is of his beloved Ipswich, Coburn's work was made from the front garden of the home that he and his mother purchased on the Thames River.

At the same time that the Orient played a pivotal role in Dow's uniquely modern photographs, so did many Western traditions, as reflected in the topics featured in the class syllabus for his last twenty-three lectures at Columbia before his death on December 13, 1922. His first nine lectures covered topics such as Egyptian handicraft, painting, and sculpture; Greek art from utensil to temple; Japanese prints, painting, and gardens; and the origins of Italian and Gothic art. The second term included a general explanation of "art structure"; Gothic architecture and crafts; Italian primitive painting; Venetian painting; Flemish and Dutch painting; landscape painting; French and Oriental art; and, finally, art in relation to other subjects.[1]

Moreover, an earlier lecture by Dow on Dutch and Flemish art, titled "Dark-and-Light," provides additional evidence that Dow was influenced by European sources. Surviving in the form of lecture notes at the Archives of American Art, Smithsonian Institution, this 1915 lecture refers to dark and light masses in works of art as "songs without words . . . a kind of music that comes to

60

JAPANESE SCREEN

Cyanotype, ca. 1893

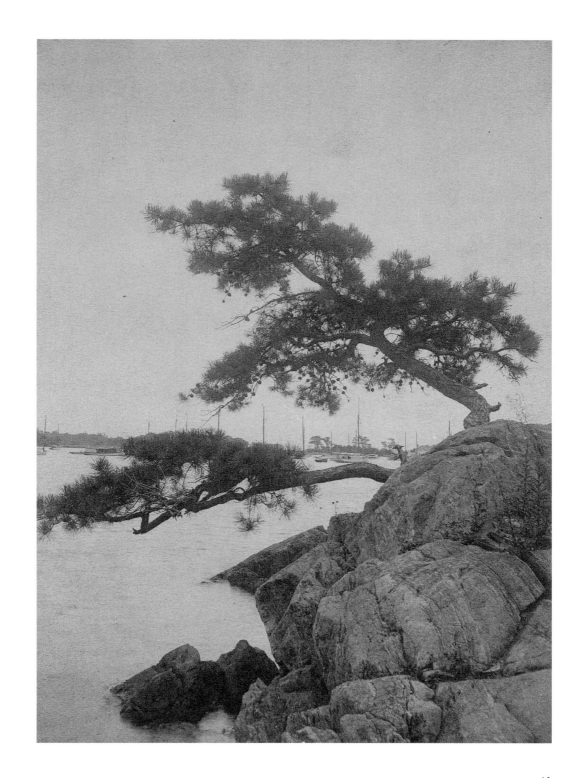

61

NEW ROCHELLE

Silver print, 1912

Collection of Roy Pedersen

62

Alvin Langdon Coburn

THAMESIDE TWILIGHT

Photogravure, ca. 1909

the eye just as sounds do to the ear." As the lecture progressed, Dow became more and more philo-sophical in an attempt to explain the aesthetic issues that he believed were inherent to fine com-position, regardless of culture or century:

> The Dutch have always been distinguished for courage, love of liberty, origi-nality, and devotion to peace and domestic life. Their art reflects their charac-ter. . . . By dark-and-light the painter can speak to the poetic and religious nature that we all have just as the musician does. . . . There is no measuring stick for art . . . Goodness that can be measured is very uninteresting. You would not think of measuring music. Art would not be worth having if we could test it in figures, or if anyone could tell us in exact words just why lines are beautiful, or why tones and colors affect our feelings. You learn the why by continually looking at and studying good things that words alone cannot describe. Something comes to you from them like the wireless waves or x rays. Do you not feel it?. . . That is the music of dark-and-light. . . . A good deal of the art of the world is in black and white only, without color, in the form of illustrations, etchings, charcoal drawings, book plates and photographs. Their value depends largely upon fine arrangement

84

63

SINGLE TREE, IPSWICH

Gum bichromate print, ca. 1902

of the dark-and-light masses. In photographs this can be partly controlled by choice of position of the camera, and by printing (Dow Papers n.d.).

In addition to giving evidence of influence, the lecture directly reflects Dow's interest in photography as a primary medium for expressing his aesthetic convictions about universal qualities in the arts.

Photographs Dow made between 1985 and the early 1900s illustrate another characteristic of his work—the use of recurring motifs. Among these photographs are ones that include motifs that occur in his paintings, sometimes in earlier paintings, other times in later ones. For example, the use of a road or path as a device to lead the eye into the center of a landscape was used extensively throughout his career (figs. 64, 65). When he explored this subject in platinum or in gum bichromate, the results were dramatically different. For example, in platinum an image would seem to be invested with the formalist characteristics of modernism while in gum bichromate an image would appear to have romantic qualities. Other motifs included haystacks, silhouettes of tree lines, close-ups of plant forms, and romantic visual poems where sky and sea became one unified study (figs. 66, 67, 68, 69).

Dow demonstrated considerable range and flexibility as an artist. In all his photographs made before 1903, Dow moved with ease among several aesthetic ideas. Photographs and paintings explored a common vision that was at once romantic and experimental. Sometimes Oriental influences would predominate, other times modernist abstractions. In one year his photographs would imitate the spontaneity of his drawings, and in another year they would reveal an awareness of a purely photographic vision. The body of work reproduced here presents, above all, an artist who was free from the expectations and demands of the photography world of his time. Without the ambition to be part of the American Photography School consisting of the Stieglitz circle, he was able to explore various photographic processes and ideas as his understanding of the medium evolved.

Dow's 1903 and 1904 trip around the world while on sabbatical from the Pratt Institute had a major impact on the range and style of his photography. It was an eagerly anticipated trip because it was Dow's first trip to the Orient and because his teaching position had been made problematic by a department head who advocated obsolete teaching methods and who was jealous of Dow's popularity (Moffatt 1977, 81–82). It was while on this trip, which included Japan, China, India, Egypt, Greece, and Europe, that Dow was by telegram offered a position at Columbia University that ultimately allowed him to pursue his belief that all the arts belonged at a single table where the banquet was about visions of the universal.

Dow's trip, on which he was accompanied by Minnie and brother Dana, began in September in Tokyo, where he was received with honor by the president at the Imperial Palace, by master craftsmen, by woodblock artists, by schools, and by civic groups. He traveled for three months in many cities, taking snapshots of the trip but also making selected elegant finished prints. Nearly

64

MEADOW WITH CREEK, IPSWICH

Platinum, ca. 1895

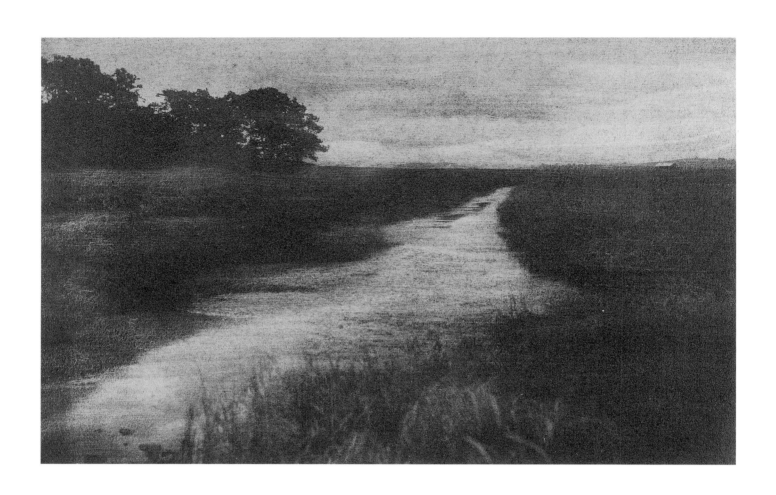

65

ROAD INTO MEADOW

Gum bichromate print, ca. 1902

66

HAYSTACKS, IPSWICH

Platinum, ca. 1894

67

THISTLE, IPSWICH

Cyanotype, ca. 1895

68

CLOUDS, IPSWICH

Cyanotype, ca. 1895

Collection of Museum of Fine Arts, Santa Fe

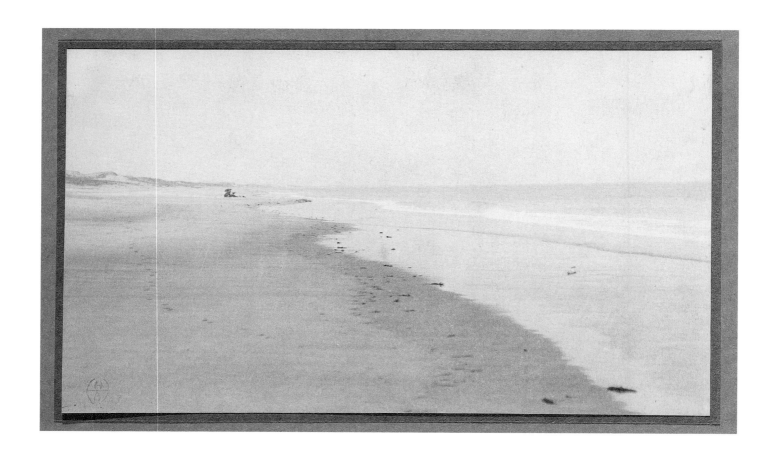

69

IPSWICH

Platinum, ca. 1900

Collection of Warren Wright

two hundred of these snapshots are in his archive at the Ipswich Historical Society, and a selection of large finished prints from the trip has survived in the collections of the lenders to the exhibition that this book accompanies and are reproduced here for the first time. Part of Dow's diaries and notes from the trip included the following entry: "Tues. Nov. 10, 1903—M. and I went to the moat beyond the Imperial Hotel to photograph the old pines on the wall. We then visited Ogawa the great photographer—he no longer deals in photographs, but publishes reproductions of master-pieces." A day later another entry read: "Dana and I photographed around Nibombashi and other places—we all went up to Uyeno to photograph Shinobayu—we took a number about the lake and on the island. Pines, old buildings—stone bridge—temples. Fine background of Uyeno Peak with its big groves of dark trees (Dow Papers n.d.)"

His mention of Dana is of interest because it is known that Dana also made snapshots now in the collections of the Ipswich Historical Society. Although several historians have speculated that Dana might have made the images for some of Dow's cyanotypes, this theory is unfounded because the cyanotypes generally reflect Dow's sophisticated artistic training. Not only the cyanotypes but all of the other photographic processes used by Dow have direct correlations to his artistic evolution and vision. There is little evidence, written or otherwise, to suggest that Dana made anything except snapshots for personal use, and although Dana kept a diary on the trip, Dow wrote about making photographs.

Dow's photographs from Japan are some of the most refined silver prints made on the trip. True to his interest in the subjects of Japanese prints, including gardens, shrines, and architecture, these photographs are among the most purely photographic (figs. 70, 71). Any sense of pictorial-ist interests inspired by the Photo-Secessionists, particularly Coburn, is nonexistent in these images. They are straightforward and take full advantage of the medium's potential for an extremely wide tonal range and exquisite detail. If Stieglitz would later praise Paul Strand's photographs as bru-tally direct, then Dow's work from Japan might be described as equally direct but with a beauty of subject more characteristic of Stieglitz's own *Flat-iron* (the Flatiron Building in winter amidst trees) of the same year. In comparing these direct images with those of his contemporaries, a perusal of *Camera Work* during the first few years of its publication reveals that Clarence White, Alvin Lang-don Coburn, and lesser-known photographers such as A. Horsley Hinton produced works of sim-ilar directness but still significantly more pictorial than those by Stieglitz and Dow.

Several years after Dow's trip he made finished prints of the Japanese images, establishing a more extreme modernist direction from which he never retreated. Those that have survived are all clearly enlargements (11 x 14 inches), printed on silver paper, and sometimes sepia toned, whereas prior to 1903 nearly all of his prints were contact prints. He also made enlargements of images taken in European cities, including Assisi and Paris as well as various locales in India, (figs. 72, 73), which similarly reflect a directness not seen before in his work, due in part perhaps to the imme-diacy of his experiences and the fact that they were documented by snapshots. It is clear from those

93

70

JAPANESE SHRINE AND CREEK

Silver print, ca. 1903

JAPANESE WATERFALL

Silver print, ca. 1903

72

ASSISI

Silver print, 1904

Collection of Robin O'Brien

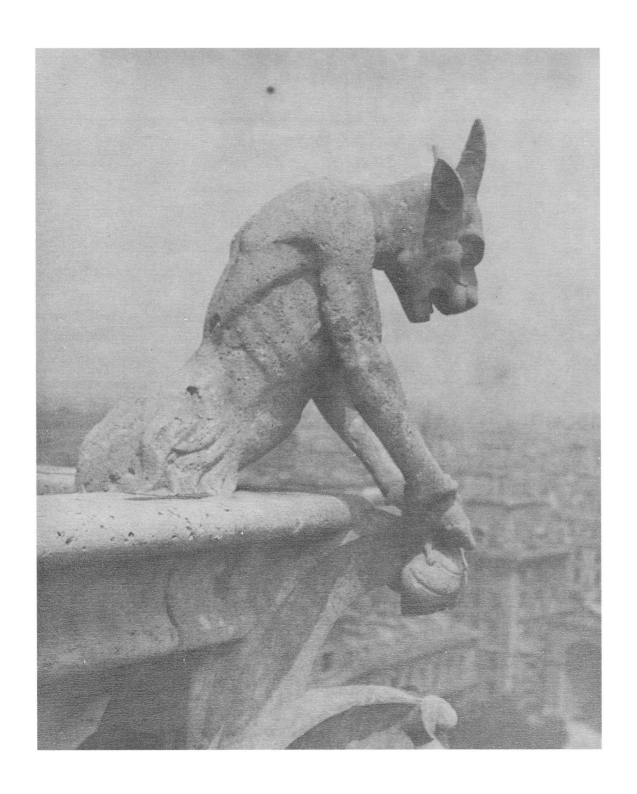

73

GARGOYLE, PARIS

Silver print, ca. 1904

he chose to print exhibition size that the images were carefully constructed, although it is possible that he discovered some exhibition-quality images among his snapshot negatives. Regardless of the artistic process used to produce these large prints, his next major photographic trip in 1911 to the Grand Canyon yielded even more dramatic prints with the same aesthetic characteristics.

Since Dow believed in simplicity in the production of art, as mentioned in his article about Käsebier, and since his prints from Paris have a wonderful handmade quality, it can be assumed that the simplest of tools were used to make the negatives and enlargements (fig. 73). For example, the Paris prints contain negative images of buttons at the margins with pinholes through the center, which were used to hold the photographic paper flat while the image was being exposed prior to development. Clearly, he did not have printing frames large enough to hold the 11 X 14-inch paper, so he made holders from buttons and pins. Such improvisation underscores the conscious effort he was making to change his aesthetic approach to photography.

A major testament to Dow's assessment of this work's quality and importance occurred when he exhibited a selection of these new enlarged images, along with his paintings and woodblocks, at the Montross Gallery from February 18 to February 29, 1908.[2] Putting this exhibition in the broader context of the New York art world, the Montross Gallery, which showed the work of impressionists as well as Edward Steichen, Dow, and others, was located at 372 Fifth Avenue, just a few doors away from 291 Fifth Avenue, where the first Photo-Secession exhibitions took place (formerly Steichen's studio). Undoubtedly, the core of the photography world saw the exhibition and took pride in the fact that, as in Stieglitz's gallery, painting and photography were being exhibited side by side; and, conversely, it was probably the Little Galleries of the Photo-Secession that inspired Dow to include his photographs in such a major exhibition at that time. Further, it is important to note that Dow's exhibition immediately followed the historic exhibition of "The Eight" (Maurice Prendergast, Robert Henri, Arthur B. Davies, and others) at the Macbeth Gallery and that Dow wrote to William Macbeth to congratulate him on showing "The Eight," who were the leading contingency of artists reacting to the conservative tradition in American painting.

The final chapter in Dow's development as a photographer took place in Los Angeles, Monterey, and the Southwest, including the Grand Canyon. He visited the Grand Canyon three times— in November 1911, January 1912 and finally in 1919 just a few years before his death. His trip to Santa Fe, New Mexico, was a revelation that only the comfort of a train could have provided since roads there were primitive and exhausting and by 1911 Dow was in his mid-fifties (figs. 74, 75). He described the New Mexico landscape as "burning bright or smouldering under ash grays . . . colour [lying] in rhythmic ranges, pile on pile, a geologic Babylon . . . high thin air, iridescent from cosmic dust, shapes and shadows seen in these vast distances and fearful deeps are blue, now vibrating with spectral hues" (Johnson 1934, 99). While visiting Laguna Pueblo, Dow took photographs that had the same power and modern vision that first appeared in his work from Japan, but now his subjects were depicted even more abstractly (figs. 76, 77). The Grand Canyon

74

INDIANS IN SANTA FE

Silver print

ca. 1911

75

ARTHUR AND MINNIE DOW AT

GRAND CANYON

Reproduction print from original

1919

76

LAGUNA PLAZA, MARY'S HOUSE

Silver print, 1911

Collection of Warren Wright

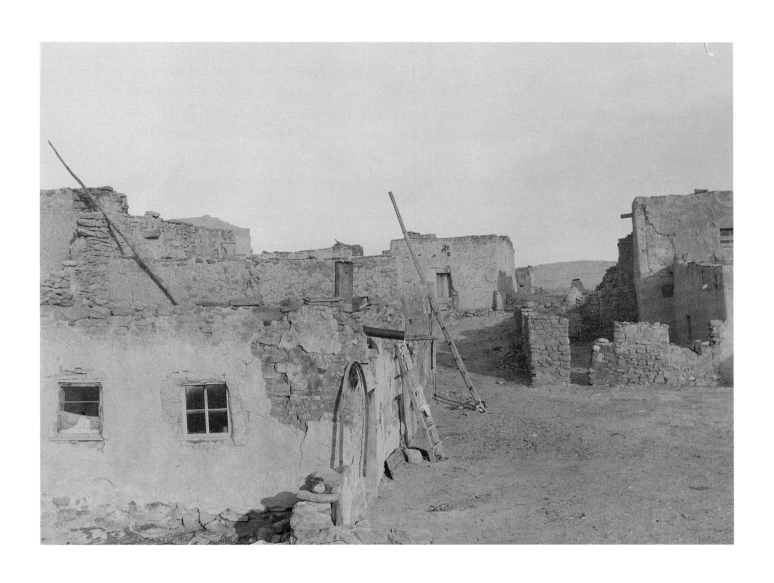

77

LAGUNA PUEBLO FROM TOP OF CHURCH

Silver print, 1911

appeared to Dow as a great and wondrous abstraction, and the images he made of it were more about the process of creating a work of art than about an idealized landscape. Residual elements of his Japanese theories gave way to a photographic layering and compression of space. Finally, his camera was utilized to explore the language of photography, which is about photography's unique lenticular representation of reality. Play with geometric shapes and space resulted in visual illusions where the horizon and the edge of a cliff came together on the same plane (fig. 79). Johnson said that Dow "stated frankly that in the work . . . he had sought to abstract the spirit of the place." He added: "This observation in his own words is interesting in the light of the various theories of the extreme modernists and radicals that sprang up in contemporary art after his death. It would

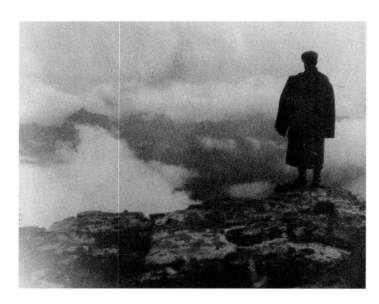

78

ALVIN LANGDON COBURN AT

GRAND CANYON

Reproduction print From original

1911

seem that Dow had anticipated ideas of others by at least a decade and put them into practice" (Johnson 1934, 99). Johnson was speaking about Dow's painting, but the paintings reveal a more Fauve-like expression, while his photographs do, indeed, anticipate the severity of modernist photography, eventually manifested in the documentary works of Walker Evans and others who made tangential space their visual signatures.

In 1911 and in 1912, Coburn joined Dow at the Grand Canyon, which, for both men, provided mystical vistas yet modern visions of deep spiritual and emotional content (fig. 78). Together, he and Dow photographed the otherworldliness of the canyon with ghostly mists rising and falling through infinite space above and below (figs. 80, 81). Some of Coburn's most admired images are from this period, and he identifies this experience as the impetus for

later creating one of his most revolutionary modernist works: "Fascinated by the natural views from high altitudes such as Mount Wilson and the rim of the Grand Canyon, the following year I photographed equally fascinating though quite different man-made views from the top of New York's skyscrapers. 'The Octopus' was taken from the top of the Metropolitan Tower, looking down on Madison Square where the paths formed a pattern reminiscent of that marine creature" (Coburn 1978, 84).

In a statement for an exhibition of his paintings from the Grand Canyon at the Montross Gallery in 1913, Dow describes his aesthetic vision of the Grand Canyon as follows: "It was this

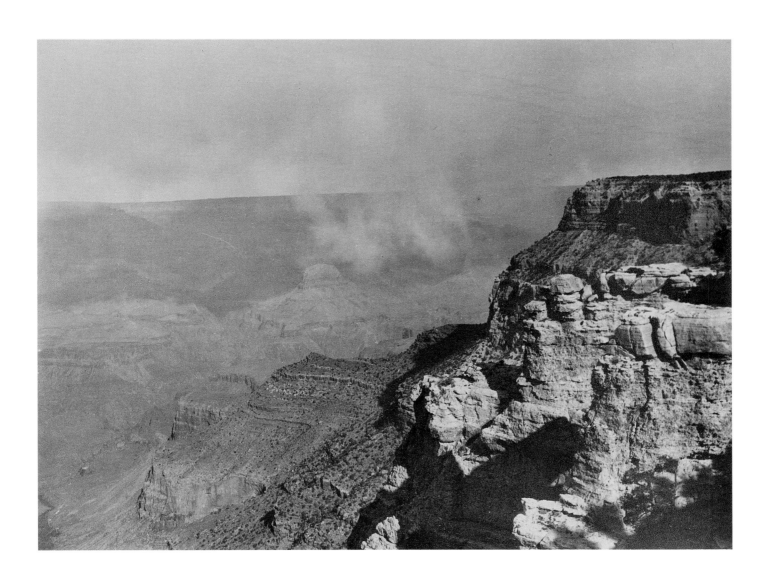

79

GRAND CANYON WITH MIST

Toned silver print, 1911

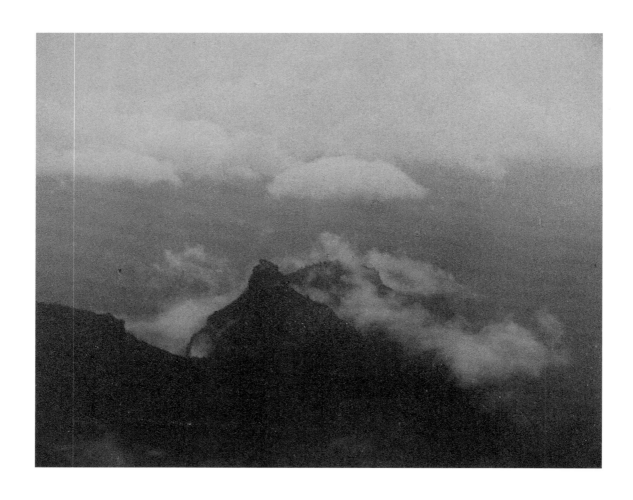

80

Alvin Langdon Coburn

GRAND CANYON SILHOUETTE OF PEAK

Platinum, 1911

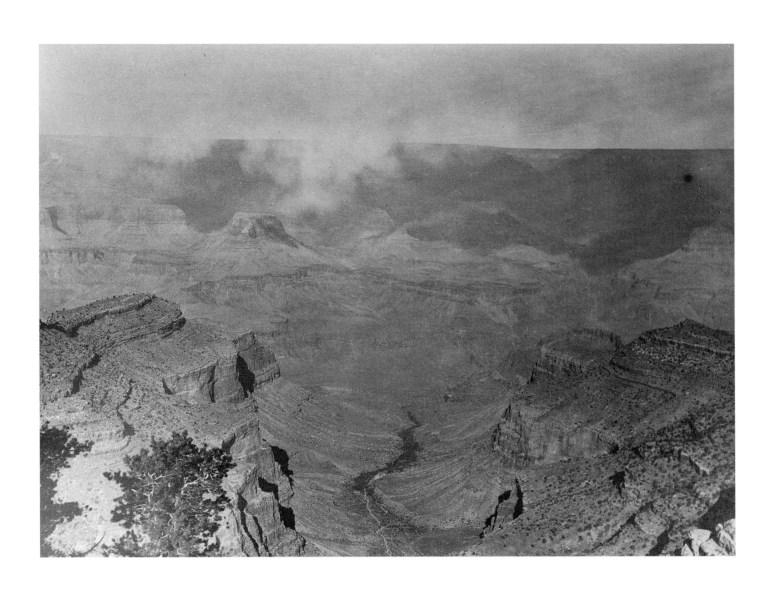

81

GRAND CANYON WITH MIST

Silver print, 1911

Collection of Roy Pedersen

line and color that interested me, hence, I did not make any vague sketches. I wanted to seize the Grand Canyon's harmonies, and those only. I hoped also to give a sense of vastness—the immense scale of everything there. . . . Every motif was carefully studied, with written notes. In some cases of special complication of line I took snapshots."[3] Dow's snapshots became, of course, the same kind of snapshots that Stieglitz referred to when he made his pioneering work *Winter on Fifth Avenue* using a hand-held camera to brave the elements of a New York storm. His studies, like Dow's, provided a vision of the next direction of American modernist photography.

A few months after Dow's death on December 13, 1922, *International Studio* magazine author George J. Cox wrote an appreciative obituary of Dow, which serves equally well as a summary of his contributions to photography: "To Arthur Wesley Dow belongs the honorable distinction of the pioneer, for he it was who cleared a path through the jungle of academic theories that hampered the progress of art at the end of the Nineteenth Century. . . . So rapidly do events move and so quickly are things forgotten that it is even now difficult to realize that it once needed a resolute pioneer to assert the truths of this artistic faith. Today it is almost a *cliché* to state that representation is not art; that appreciation should precede or at least accompany execution; that a work of art should be instinct with spirit and imagination as well as technical skill" (Cox 1923, 189, 191). A modest and shy man, Dow never sought recognition for his most radical contribution to the arts. He was content to find satisfaction in the photographs he made and in giving freely to his friends and peers whatever aspects of his search could serve the greater good.

1. A copy of the syllabus is in the collection of Barbara and George Wright. The syllabus heading was "Subjects of Lectures 1921–1922." The lectures were scheduled to be delivered in a sequence of three to four per month.

2. Eight photographs were included in the exhibition. The original brochure in the collection of Barbara and George Wright lists the photographs as being of India, Greece, and Egypt.

3. From an original page of notes in the collection of Barbara and George Wright.

Plates

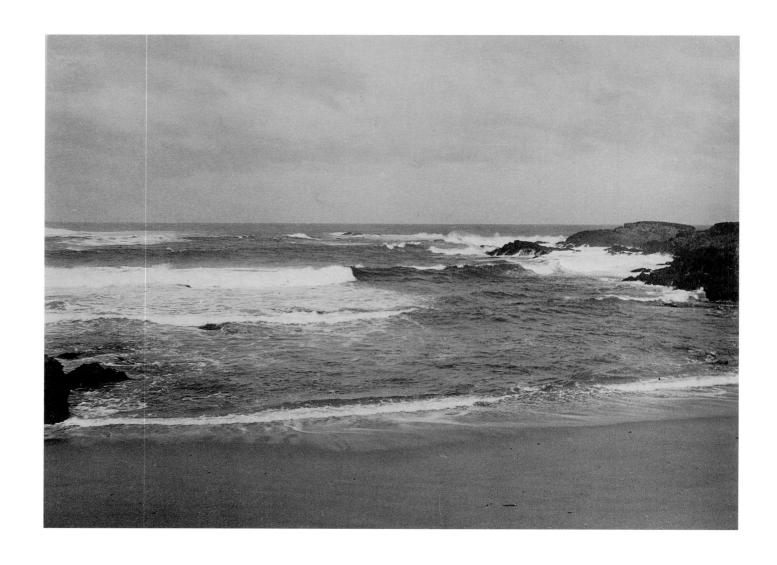

82

PACIFIC OCEAN, PACIFIC GROVE, CA

Silver print, 1912

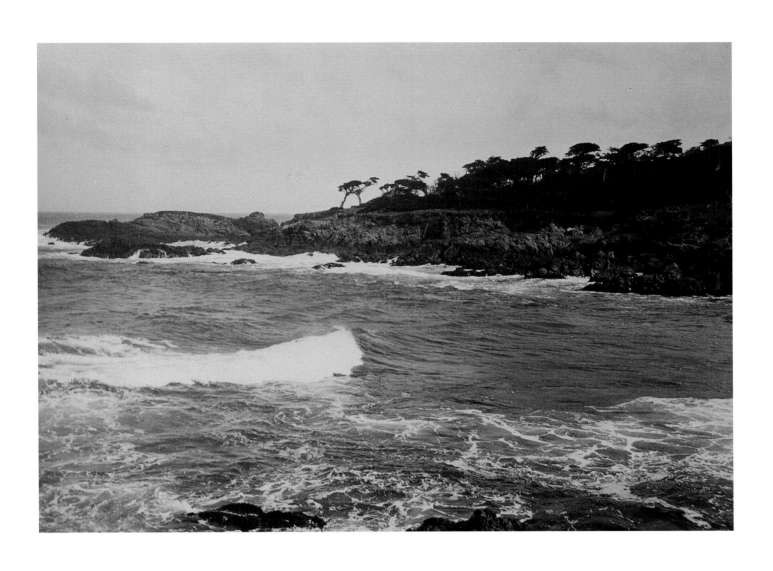

83

PACIFIC GROVE

Silver print, 1912

Collection of Roy Pedersen

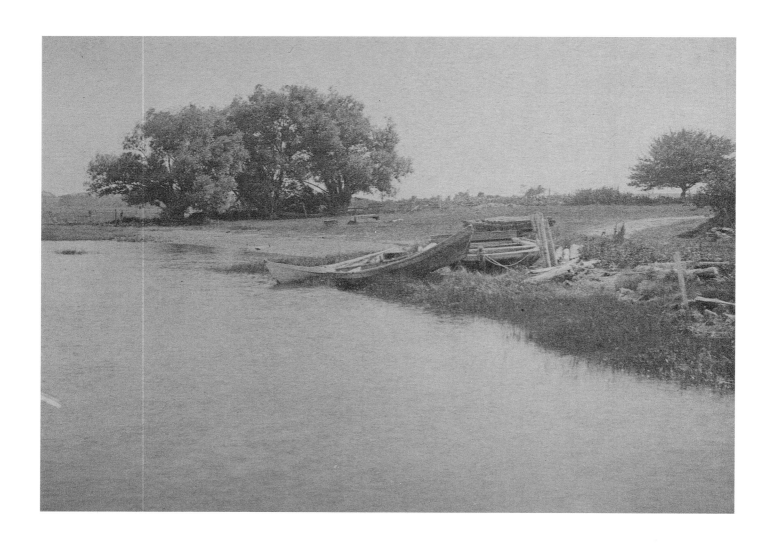

84

BOATS ON RIVER, IPSWICH

Platinum, ca. 1895

85

BOAT AND CLAM HOUSE, IPSWICH

Platinum, ca. 1895

86

JAPANESE LOTUS POND IN WINTER

Silver print, ca. 1903

87

TREE ON LAKE, IPSWICH

Platinum, ca. 1900

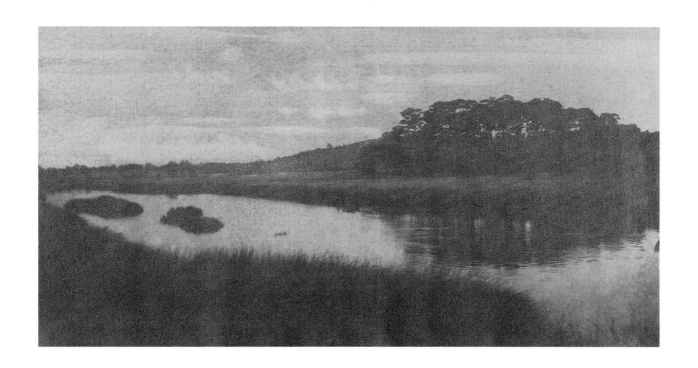

88

MEADOW AND MARSH

Gum bichromate print

ca. 1902

89

EUCALYPTUS, CALIFORNIA

Silver print, 1912

Collection of Roy Pedersen

90

ARROYO SECO, CA

Silver print, 1912

Collection of Roy Pedersen

91

TREE LINE, IPSWICH

Platinum, ca. 1895

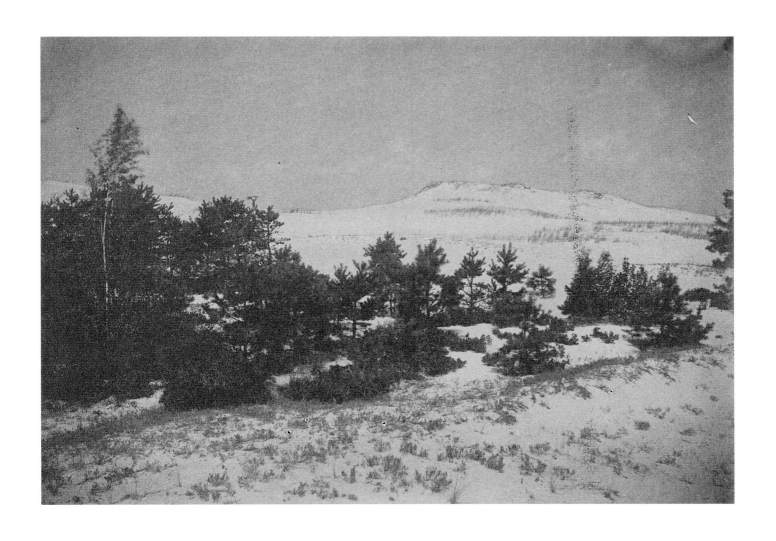

92

WINTER LANDSCAPE, IPSWICH

Platinum, ca. 1895

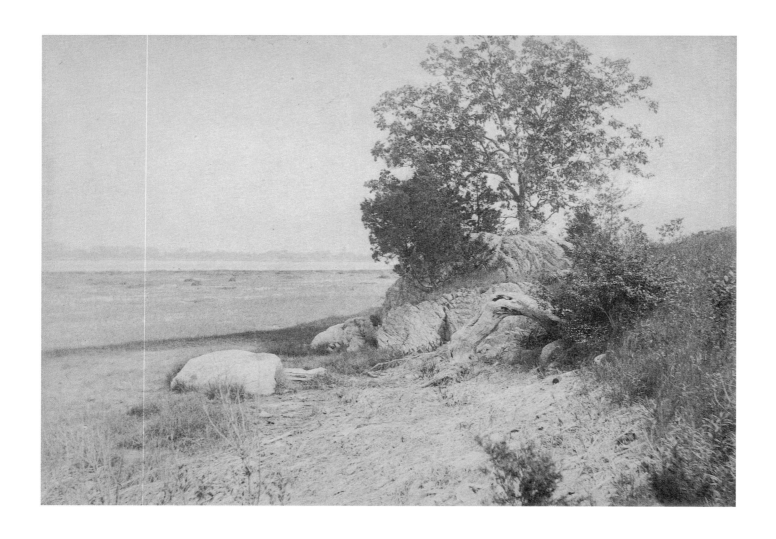

93

ROCK AND SANDY OUTCROPPING, IPSWICH

Platinum, ca. 1895

94

DUNES AND TREES, IPSWICH

Gum bichromate print, ca. 1902

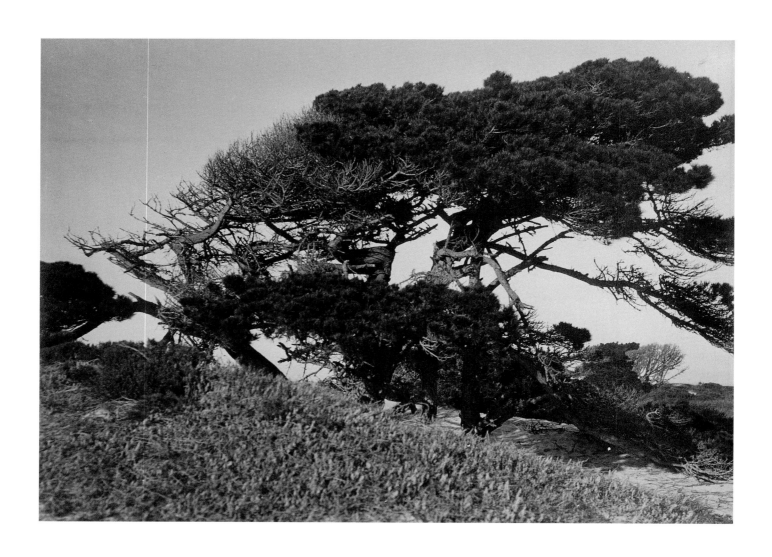

95

CALIFORNIA CYPRESS

Silver print, ca. 1912

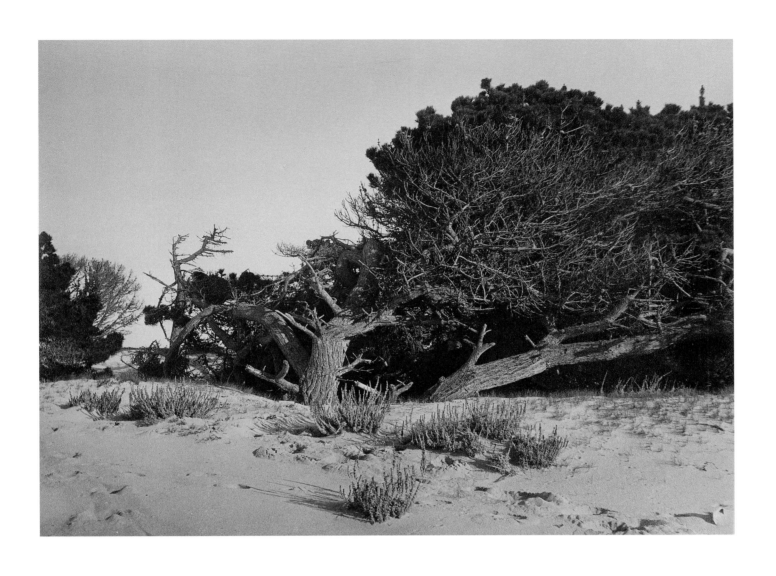

96

CALIFORNIA DUNE AND CYPRESS

Silver print, 1912

97

MEADOW WITH ROCK, IPSWICH

Platinum, ca. 1900

98

MEADOW AND TREES, IPSWICH

Cyanotype, ca. 1895

99

ROCKWALL IN MEADOW, IPSWICH

Cyanotype, ca. 1890

100

FLOWERS IN MEADOW, IPSWICH

Cyanotype, ca. 1895

101

LILIES IN MEADOW, IPSWICH

Cyanotype, ca. 1895

102

TEMPLE, INDIA

Silver print, ca. 1904

103

TEMPLE, INDIA

Silver print, ca. 1904

104

TEMPLE, INDIA

Silver print, ca. 1904

105

BATHERS IN INDIA

Silver print, ca. 1903

106

CHINESE FISHING VILLAGE NEAR MONTEREY, CA

Toned silver print, 1912

107

DOW STUDENTS IN

JAPANESE SETTING, IPSWICH

Platinum, ca. 1905

108

JAPANESE GARDEN AND HOUSE

Silver print, ca. 1903

109

JAPANESE STONE LANTERN AND GARDEN

Silver print, ca. 1903

110

JAPANESE HOUSES WITH

BRIDGE AND POND

Silver print, ca. 1903

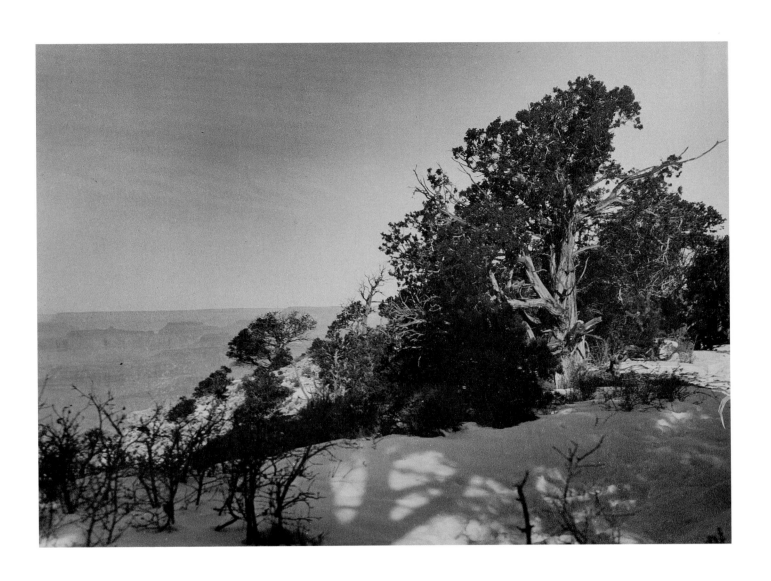

111

GRAND CANYON, WINTER

Silver print, 1912

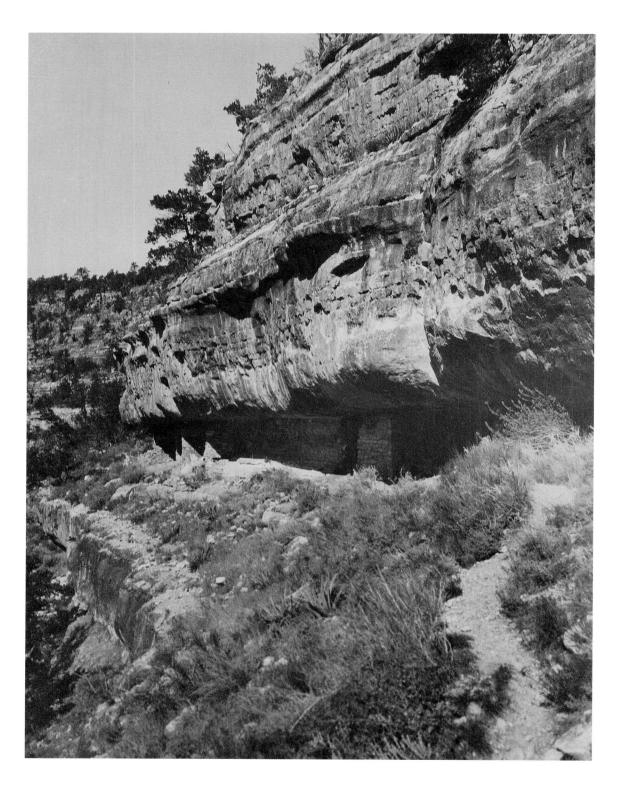

112

CLIFF DWELLING

Silver print, 1911

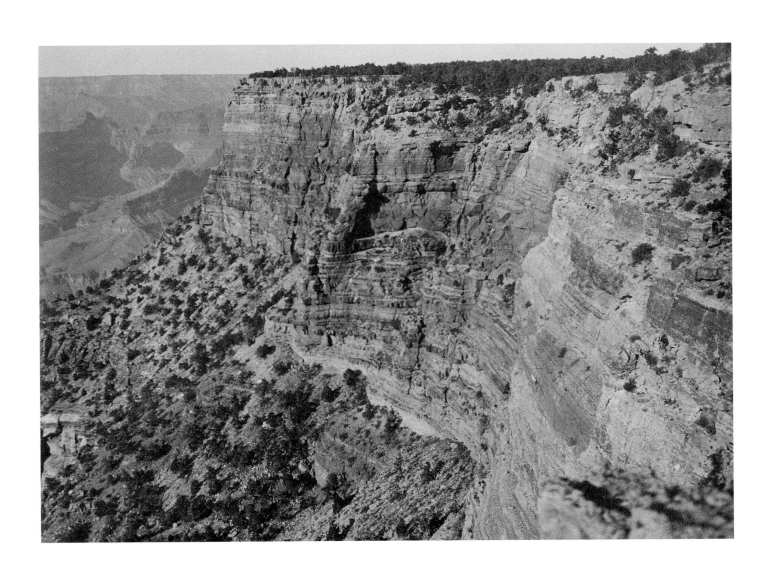

113

BRIGHT ANGEL CANYON FROM

YAVAPAI TRAIL, GRAND CANYON

Silver print, 1911

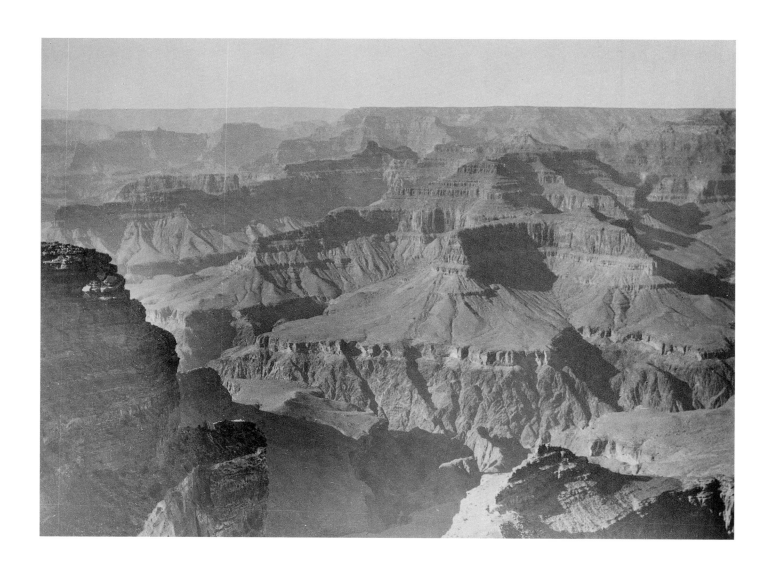

114

GRAND CANYON OF ARIZONA

Silver print, 1911

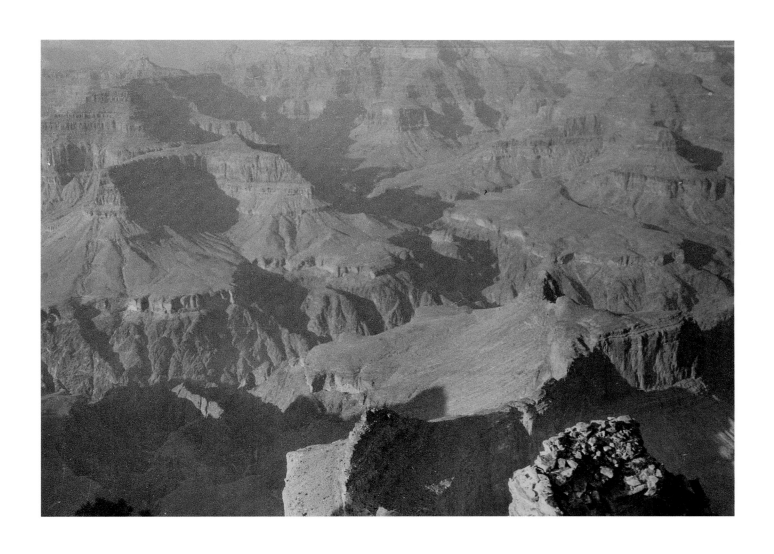

115

GRAND CANYON

Silver print, 1911

Collection of Warren Wright

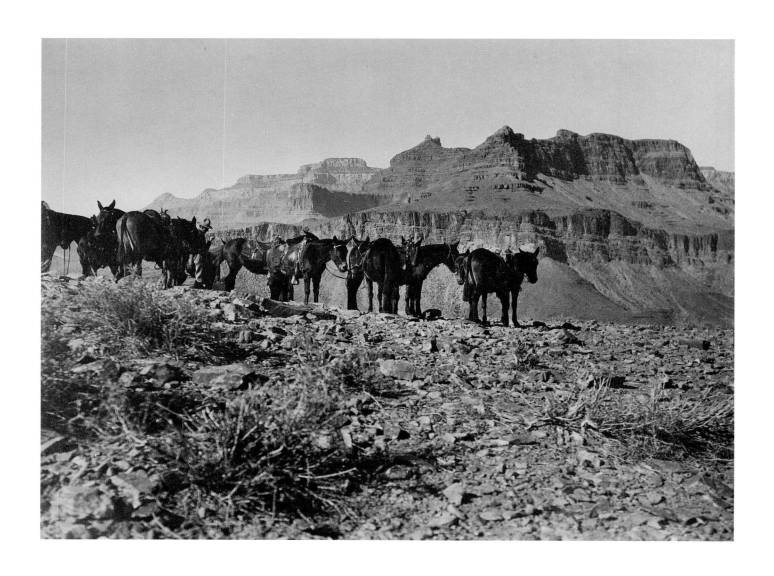

116

AT PLATEAU, BRIGHT ANGEL TRAIL

PACK TRAIN, GRAND CANYON

Silver print, 1911

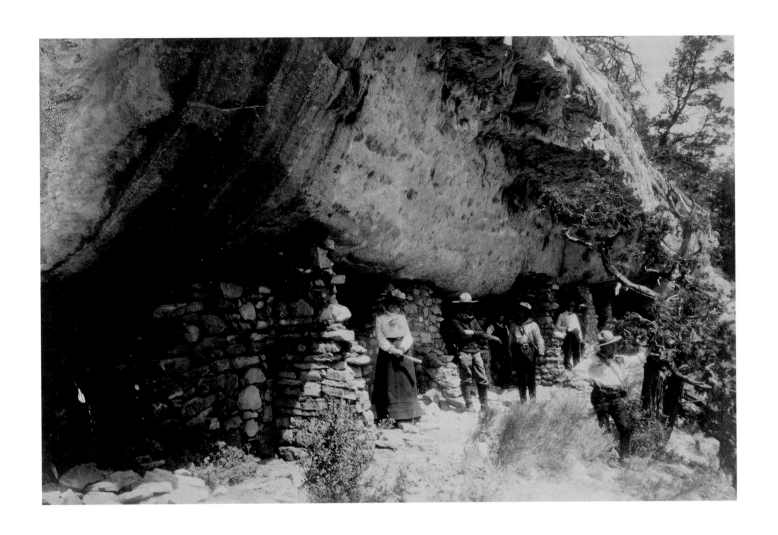

117

TOURISTS AT CAVE DWELLING

Silver print, 1911

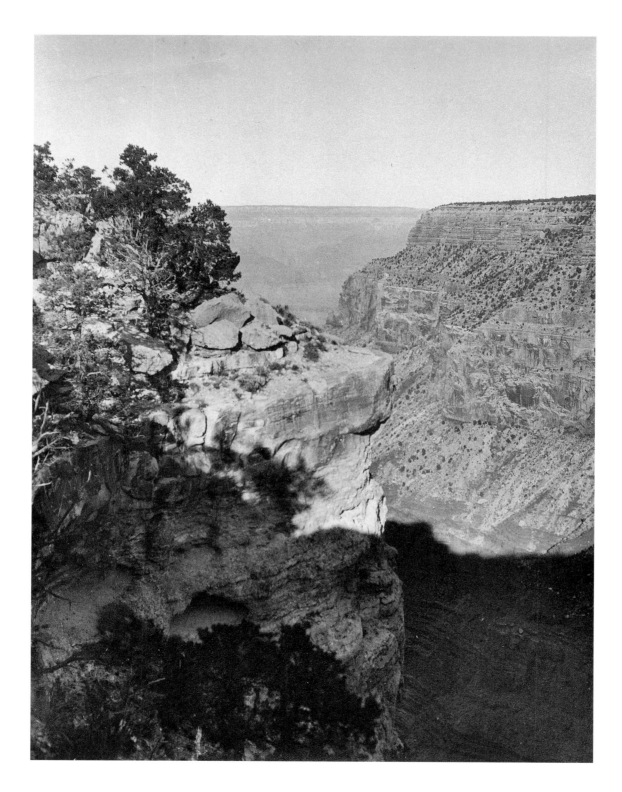

118

GRAND CANYON, ARIZONA, FROM RIM ROAD

Silver print, 1911

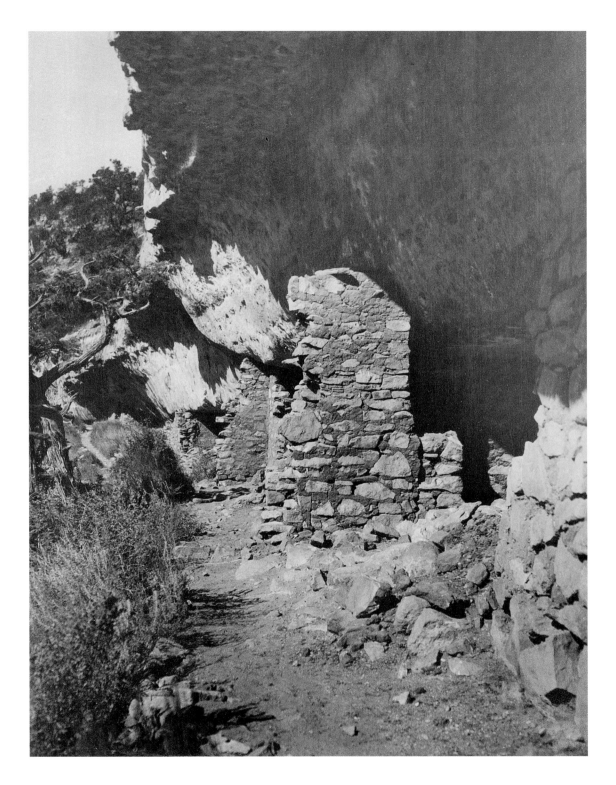

119

CLIFF DWELLING, FLAGSTAFF, AZ

Silver print, 1911

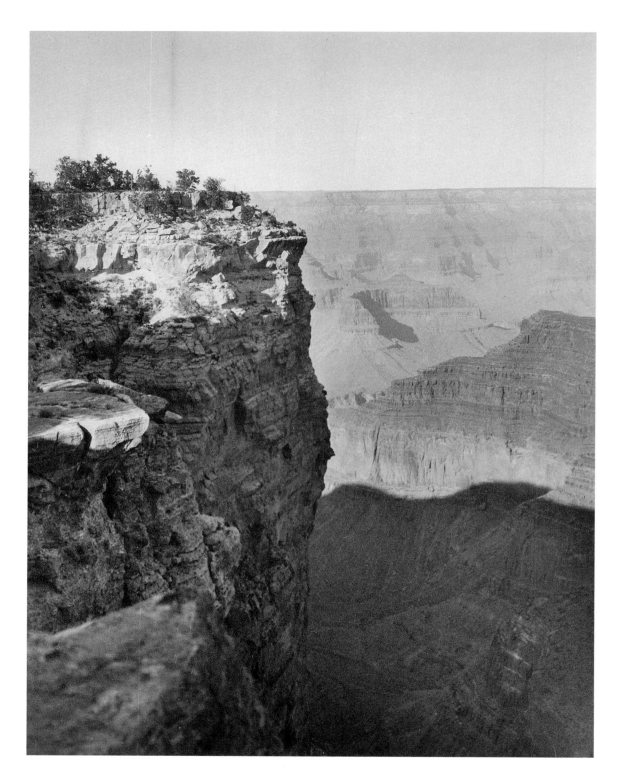

120

GRAND CANYON, SHADOW ON CANYON FLOOR

Silver print, 1911

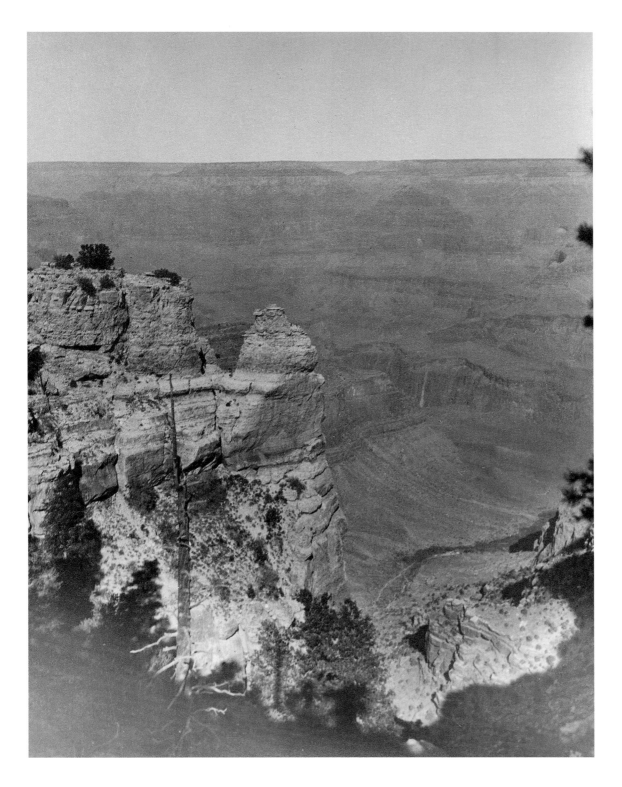

121

ON YAVAPAI TRAIL, GRAND CANYON

Silver print, 1911

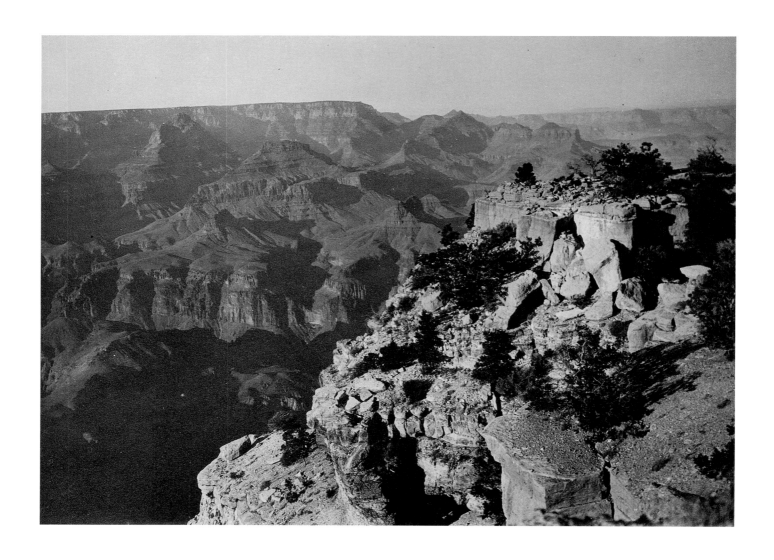

122

GRAND CANYON

Silver print, 1911

Collection of Roy Pedersen

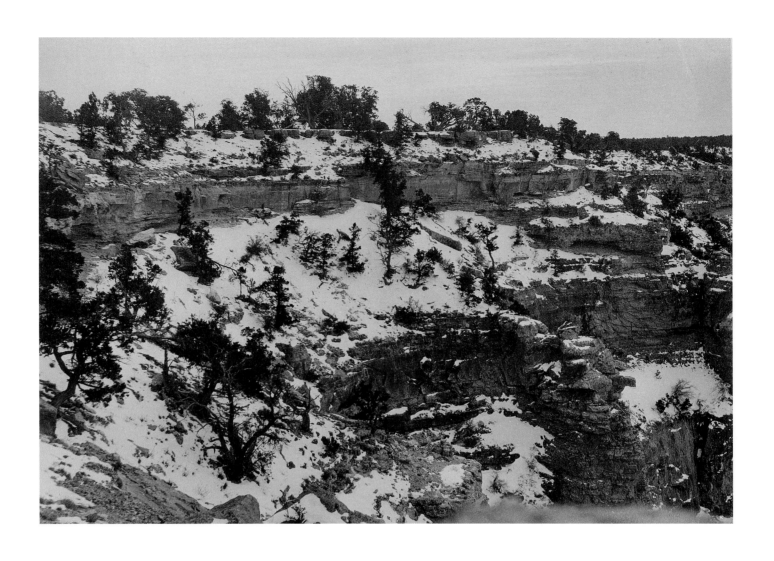

GRAND CANYON RIM IN WINTER, YAVAPAI POINT

Silver print, 1912

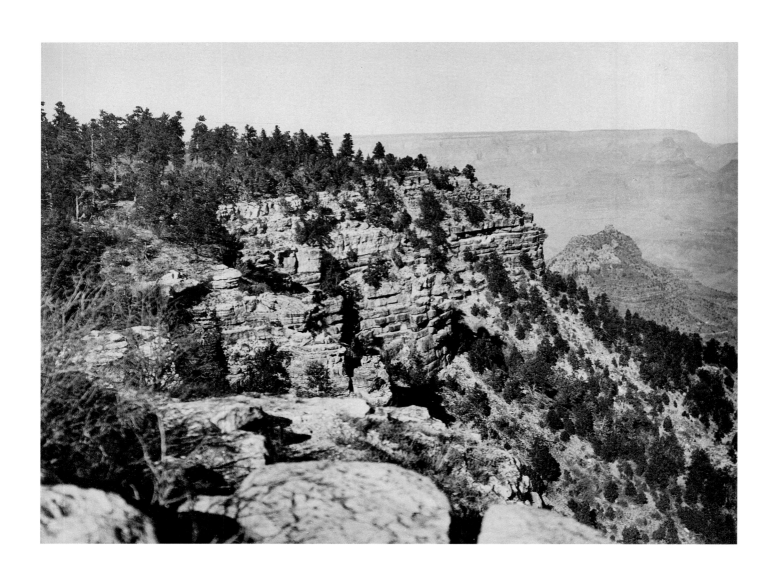

124

GRAND CANYON, TREE COVERED BLUFF

Silver print, 1911

125

FIRST FOREST (petrified tree)

Silver print, 1911

126

NORTH SIGILLANA, ONE TREE (petrified)

Silver print, 1911

127

FIRST FOREST (petrified tree)

Silver gelatin, 1911

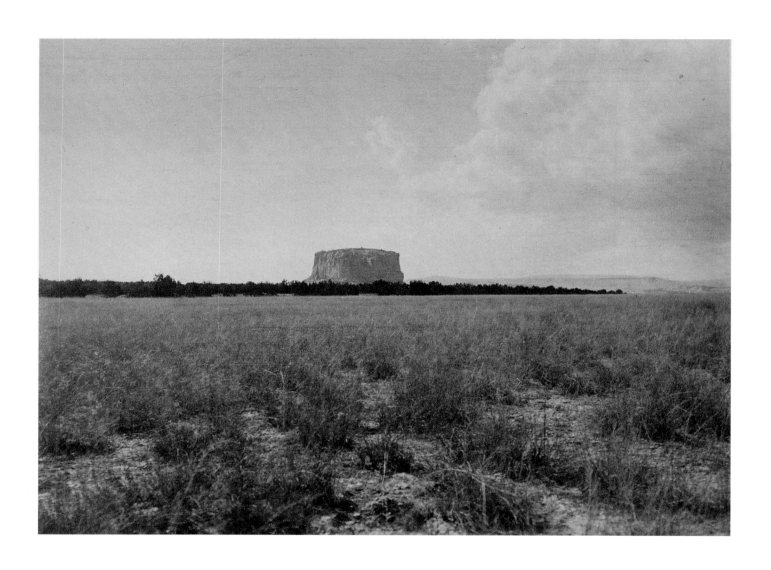

128

DESERT MESA

Silver print, 1911

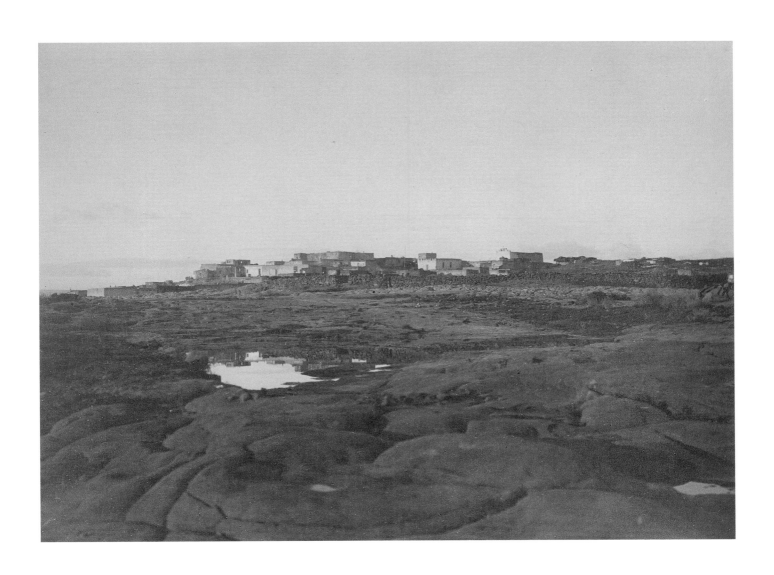

129

LAGUNA VILLAGE

Silver print, 1911

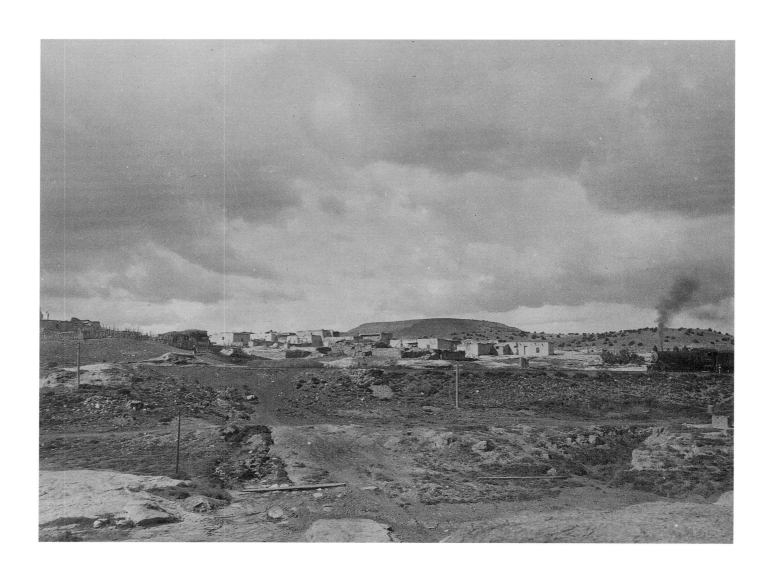

130

LAGUNA WITH TRAIN

Silver print, 1911

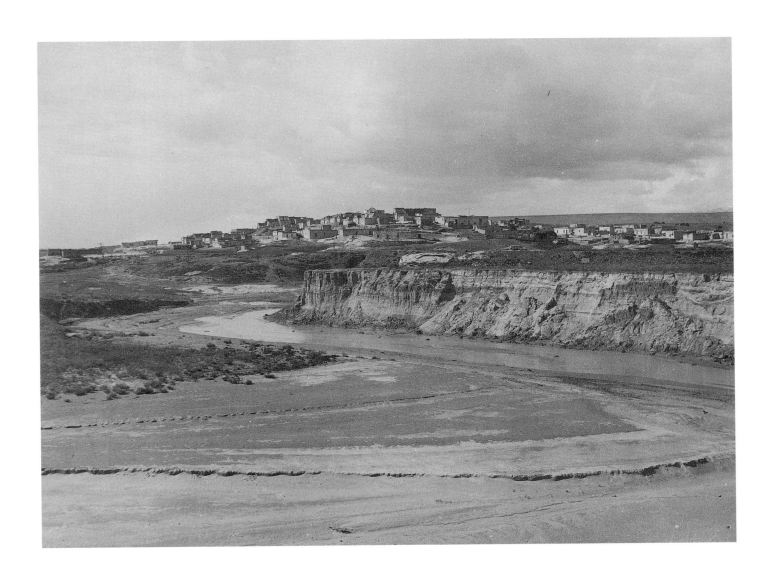

131

LAGUNA VILLAGE AND RIVER

Silver print, 1911

W HEN I FIRST BECAME ACQUAINTED with my great-uncle Arthur, I was seven and he had been dead for some fourteen years. He no longer walked the shores of Turkey Creek, greeted a friend at the door of an old Ipswich house, or gazed out over the islands that broke the seascape with its ever-changing colors. But through the eyes of Dow's sister-in-law, my great-aunt Winnie, Dow became so vibrantly alive for me that even these many years later I can almost see him working with painstaking concentration as he daubed paint onto canvas or cut scenes of his native New England into wooden blocks. We know that he dragged his camera throughout the far reaches of the world, stopping to gain just the correct perspective on a temple in India, a lone street in Assisi, or to catch the light of the setting sun on a jutting rock of the Grand Canyon. Aunt Winnie never told me if he cocked his head to one side or knelt to capture another view of his subject, but we can still see his conjured images held in time.

It was late summer 1936 when Aunt Winnie first took my hand to lead me up the hill to the rugged stone that marks his grave. I am sure I broke away to run over the crest of the hill to look out over the ocean. She must have called me to notice how the sea wound its sinuous blue way around the green outcroppings "like a dragon," she said.

I do not know if Aunt Winnie's small white frame house still stands, but in the way that memory allows, I can see myself climbing the hill to the henhouse on the edge of the deep woods or walking the uneven ground of the orchard in search of apples ripe enough to eat in August. No longer recalling myself in the third person, I can smell the purple phlox and feel the morning sun on the wet grass. The twin mysteries of seeing oneself and being oneself can take me back into the darkened parlor where old highboys and low trunks held their treasures and rendered their contents only when Aunt Winnie proclaimed their freedom on a rainy day. She, a magician, my brother and I wide-eyed participants in a ritual I remember well.

As thunder rumbled, we watched her bend over to open the heavy lid of the first trunk. In happy anticipation, we waited to see the wonders Uncle Arthur had brought back or fashioned with his own hands and eventually left to his brother's wife, Winifred. On those wet afternoons she became a merchant in a Mideast bazaar, a Chinese trader from Canton, or a haughty French dressmaker. She held shimmering silks and heavy satins; she draped strange embroidered flower designs on my shoulders and counted into my brother's hands small green scarabs. Other trunks held Japanese prints. The thin rice paper with the dry feel of filo dough showed the flat faces of warriors and courtesans and the intricate and complicated designs of their costumes. Packed carefully in sheets of tissue were tiny woodblock prints of fishing huts in early dawn or purple twilight; slanted rain on pink apple blossoms; and spiked orange desert flowers at the end of day.

Yet another trunk's contents allowed us to travel the world as we held large brown photographs, shuffling them to choose the story. We became part of a wagon train moving west, a mesa looming in the distance. We supped with Southwest Native Americans in their pueblos and even climbed high over Paris to peer at a frightful gargoyle on a tower of Notre Dame.

Years later, Uncle Arthur's handmade blue-and-white rug that bears the Tree of Life was the first image our granddaughters saw from their cribs, and his photographs have allowed all our grandchildren to travel the world as we once did with Aunt Winnie. Although I have never returned to her house, I have made the journey to Ipswich several times, and with each trip I am struck by the fact that Summer Street has not changed. And though the fishing shacks no longer hug the shore along the bay, it is easy to imagine them still there, as Dow photographed them. Now the cool color of the Massachusetts coastline is magically transformed into the blue cyanotype I can hold in my hand. Color was left to us. Shapes in harmonious design were left to us. I look at the ocean caught in pale sepia and feel again the sand between my toes, smell the salt, the seaweed, the fish, and breathe in a timeless joy only a work of art can give.

Arthur Wesley Dow passed on his creations to his wife, Minnie, then on her death they were given to his brother, Dana, who in turn left them to his own wife, Winifred. Childless, Winifred left the collection to her only niece, my mother, Virginia. The death of my mother caused the collection of prints, paintings, and fabric to come to my siblings and myself. Dow's photographs, mostly unknown by those who knew his art, were my particular responsibility and treasure.

I am delighted to be able to share this photographic collection with a wider public in the form of this book and exhibition.

Caffin, Charles. 1997.
"Some Prints by Alvin Langdon Coburn." In *Alfred Stieglitz: Camera Work, the Complete Illustrations, 1903–1917*. Ed. Simone Philippi. Cologne: Taschen.

Coburn, Alvin Langdon. 1978.
Alvin Langdon Coburn: Photographer, An Autobiography. Eds. Helmut and Alison Gernsheim. New York: Dover Books.

Cox, George J. 1923 [1902].
"The Horizon of A. W. Dow." In *International Studio*, vol. 77, no. 313 (June).

Denis, Maurice. 1982.
"From Gauguin to Van Gogh to Classicism." In *Modern Art and Modernism: A Critical Anthology*. Eds. Francis Frascina and Charles Harrison. New York: Harper and Row.

Dow Papers. n.d.
Archives of American Art, Smithsonian Institution, Washington, D.C.

Dow, Arthur Wesley. 1895.
"Printing from Wood Blocks." In *Special Exhibition of Color Prints, Designed, Engraved, and Printed by Arthur Wesley Dow*. Ex. Cat. Boston: Museum of Fine Arts.

_____. 1899–1900.
"Mrs. Käsebier's Photographs, from a Painter's Point of View." *Camera Notes*, vol. 3.

_____. 1997 [1920].

Composition: A Series of Exercises in Art Structure for the Use of Students and Teachers, 13th ed. Berkeley and Los Angeles: University of California Press.

_____. n.d.

"A Day with Dr. Hyslop." Arthur Wesley Dow Papers. Private Collection of Barbara and George Wright.

Green, Nancy. 1999.

"Arthur Wesley Dow: His Art and His Influence." In *Arthur Wesley Dow: His Art and His Influence*. New York: Spanierman Gallery.

Greenough, Sarah. 1998.

Alfred Stieglitz: Photographs and Writings. Washington, D.C., and Boston: National Gallery of Art in association with Bulfinch Press, Little, Brown and Company.

Johnson, Arthur Warren. 1934.

Arthur Wesley Dow: Historian, Artist, Teacher. Ipswich, New York: Ipswich Historical Society.

Moffatt, Frederick C. 1977.

Arthur Wesley Dow: 1857–1922. Washington, D.C.: Smithsonian Institution Press.

Niven, Penelope. 1997.

Steichen: A Biography. New York: Clarkson Potter.

Peterson, Christian A. 1992.

"The Photograph Beautiful, 1895–1915." In *History of Photography*, vol. 16, no. 3 (Autumn).

Smith, Joel. 1999.

Edward Steichen: The Early Years. Princeton, N.J., and New York: Princeton University Press in association with the Metropolitan Museum of Art.

Sutton, Denys. 1966.

Gauguin and the Pont-Aven Group. London: Arts Council of Great Britain.